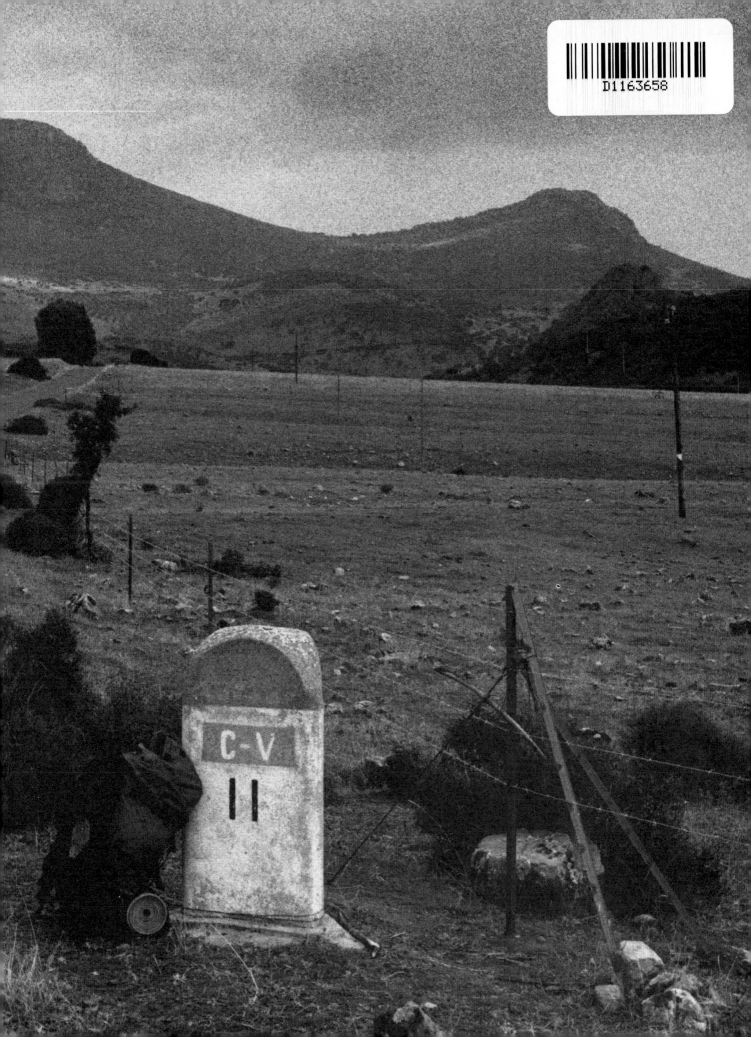

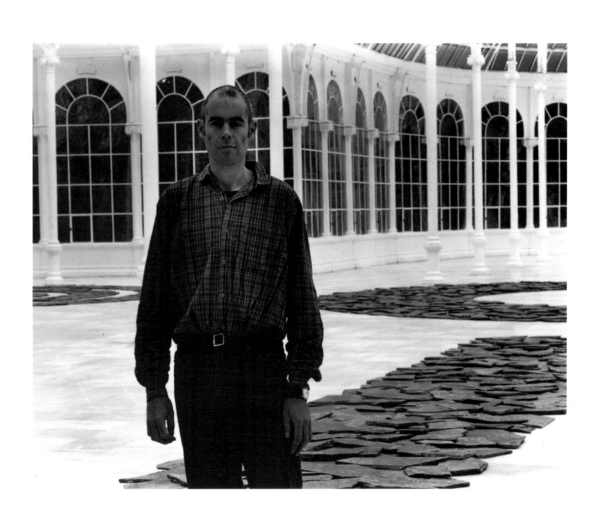

GLORIA MOURE

RICHARD LONG

SPANISH STONES

Ediciones Polígrafa

Concept and design
Richard Long

Editing and text
Gloria Moure

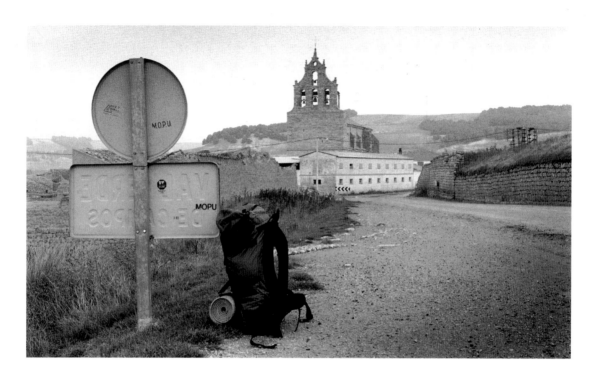

Translator
Richard Rees

Lay-out
Jordi Domingo

Typeface
Gill Sans

Colour separation
Format Digital

Typesetting and printing
Alva Gráfica

Binding
Encuadernaciones Bárdenas

© of the Edition: 1998, Ediciones Polígrafa SA, Barcelona
© Text and translation: the autors
© Photographs: Richard Long; except pag. 4 courtesy of X. Lobato; pag. 25 courtesy of Galería Weber, Alexander y Cobo;
 pag. 31 courtesy of Enzo Ricci; pag. 65-99 courtesy of Prudence Cuming Associates Limited, London.

ISBN 84-343-0881-9

Dep. legal: B. 6318-1999

Printed and bound in Spain

Contents

Richard Long, the landscape recovered 11
Gloria Moure

Works in Spain 1985-1994 36

River Avon Mud Drawings 1995 64

Biography 101

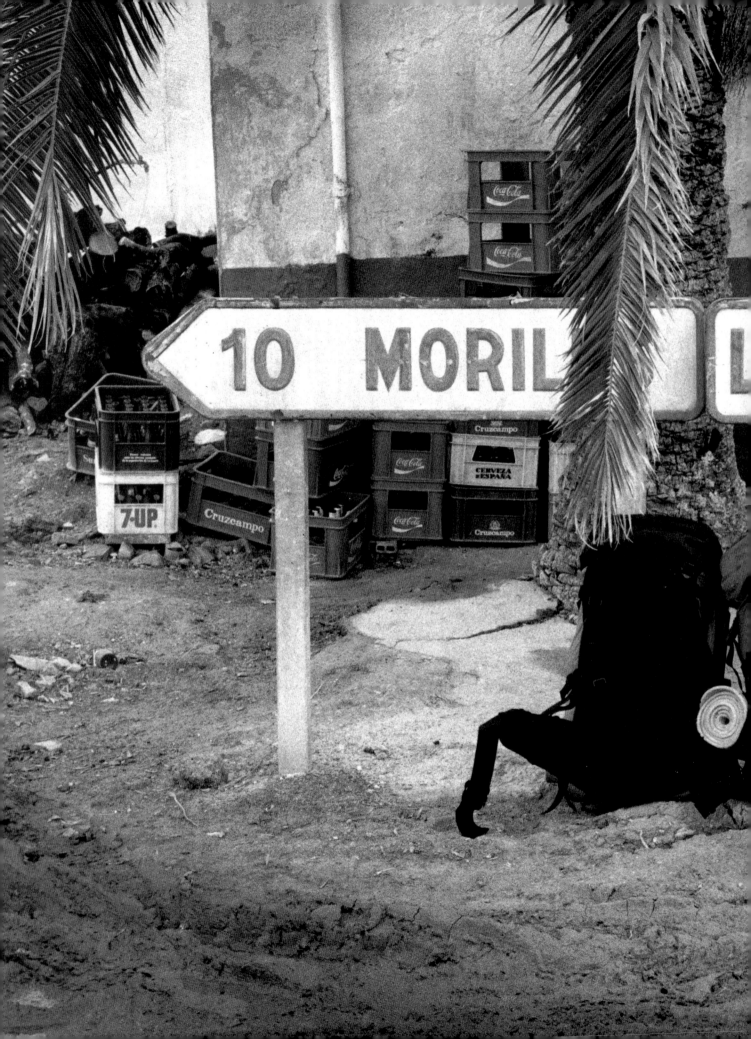

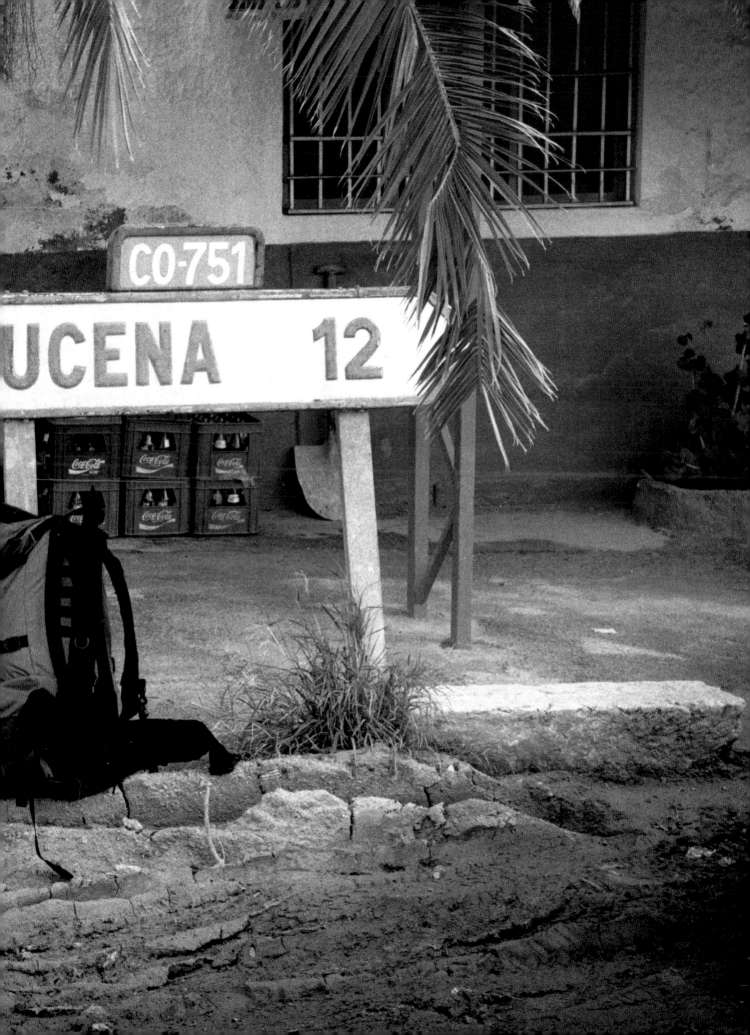

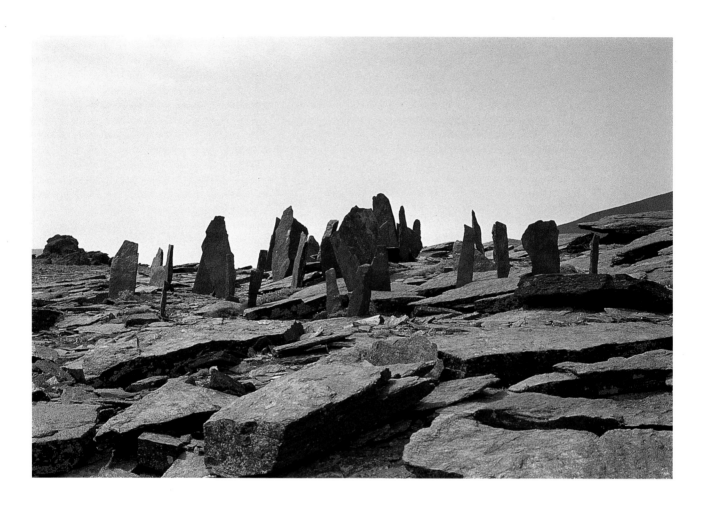

SIERRA NEVADA STONES

A FOUR DAY WALK
SPAIN 1985

RICHARD LONG, THE LANDSCAPE RECOVERED Gloria Moure

THE KEY TO THE LANDSCAPE

The pursuit of maximum expressive economy as a paradigmatic constant characterises the whole of Richard Long's artistic career. Indeed, simplicity reigns over both his sparing formalisations and his ascetic landscaping actions as a kind of supreme restriction. Nevertheless, it is a paradoxical fact that all the dialectical elements that have underlain modern creation since the early XIX century, including the relatively recent challenges to the very concept of modernity as predominantly understood during the XX century, criss-cross each other in arcane complexity in his work.

On the other hand, and this is a crucial factor when it comes to providing a suitable framework for this essay, it must be noted that Long belongs in terms both of age and convictions to the sixties generation. However, in relation to this evident truth that the artist himself would be the first to confirm, I should qualify the commonly held view according to which this decade forms a solid, homogeneous ideological "corpus" and a perfectly delimited time interval. As regards this latter point, the seeds of protest had already germinated with virulence halfway through the previous decade and, furthermore, the influence of such germination persisted well into the seventies. Regarding social, political and aesthetic issues, several different stances were adopted that were not always correlatively linked. What in my opinion is really important about that decade, however, is the fact that above all in the artistic field, although parallels may also be detected in many other ambits of knowledge, a genuine fracture was produced from mid-decade onwards that dislocated the apparent protest regularity and split the decade into two well-differentiated segments: a first one that we might define as continuing on from and constituting the ultimate expression of most of the historical avant-gardes; and a second, which I would dare label as revolutionary, that questioned the rationalist idea of progress and attempted to revise and reconstruct creative approaches as a whole. Although invariably respectful of tradition, Richard Long belongs fully and with every right to this courageous revisionist block of the late sixties. Richard Long's is not the only case in point, of course, but it stands out by virtue of the fact that his work, which I suggest should always be analyzed as a continuous flow, and therefore as a body, has directly to do with landscape, a theme that more as a structure of expression than as a representative motif I have invariably taken as a technical key and guideline to the review of art history. In this sense, of course,

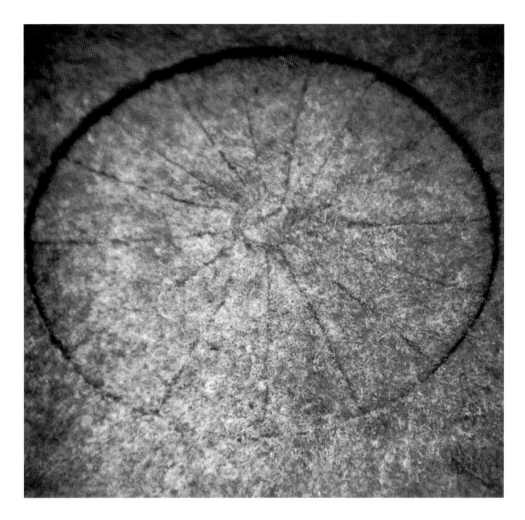

TURF CIRCLE
ENGLAND 1966

I refer not only to contemporary art but to the art of all periods, including the earliest. Indeed, during the XIX century the landscape played a fundamental aesthetic role as a vehicle for the artistic quests of Romanticism, Naturalism, Social Realism and Symbolism alike. Nevertheless, the fact that it also played this role for Impressionism and Postimpressionism meant in the long run its progressive loss of prominence vis-à-vis the human figure and the still life, both academic terms understood in the loose sense. This drift, which I consider pernicious, was the result not of inner drives exclusive to art but rather of substantial changes undergone by the Western concept of the world. In the same way that from the XVII to the XIX centuries language was a representation of representation, that is, something that interpreted or, better said,

described perceptions in an orderly way according to compositional principles, artistic configuration detailed reality in terms of its wrapping, on the basis of the idea that what was important were the extrinsic characteristics of things and their possible formal concatenation, depending on the extent to which they contributed to the harmonious whole. Science, naturally enough, also responded to this cognitive approach. As from the XIX century, all fields of knowledge modified their approach to reality, art included of course. A transition was made from globality to fragmentation and from description of the visible, through likeness and symbol, to the discovery of inner structures hidden from the sensations. This generated a new universe of relationships and causalities that, though far more complex, was apparently much less arbitrary since the field of interpretation was reduced. It was an objective, mechanist vision, obsessed with empirical truth, which finally extended to all disciplines which, in turn, established the bases for their own differentiated philosophy to explain their autonomous development. In the new context, everything tended towards fostering belief in a determinist world clearly defined by objective relationships, in which the inner structure of things and of their dynamics, phenomena, constituted the only consistent reason to justify their grouping. Parts came to predominate over the whole and an exacerbated scientism impregnated all intellectual activity, including reflection on the human being, by now converted into an object and into the central motif of several social sciences. Knowledge through the senses and the role of man as sovereign interpreter went into open decline, besieged by psychology, sociology, economics and the philosophy of history. In this way, individual criteria and opinions, elements crucial to the enlightened effervescence, became reviled by a petrified modernity that seemed to be interested only in its own idealised scientific whims, consecrated as idols. Furthermore, this scientistic concept of the world took from former theological knowledge the teleological dynamic towards ever more perfect states, formalised in a linear progressism as coarse as it was elementary. Language itself, converted into a blind structure, seemed to engulf philosophy to transform it into pure formal logic or into psychoanalysis, thus reducing the metaphysical space to minimal expression.

This was the epistemological context in which I was deliberately educated, as I assume were most readers of this text. Evidently, the objectivising frenzy, the relentless hounding of interpretation and of metaphor, and the obsession with analysis of the particular did not in any way favour the idea of landscape as an expressive configuration. As I pointed out earlier, it was in Impressionism and Postimpressionism that this decline became evident from the viewpoint of the inner logic of configuration. Behind the idea of impression was the concept not of immateriality (saving rare exceptions) but rather

those of objectivity and credibility. To make the step from here to appreciation of pure colour and to the sublimation of the geometry of pictorial planes was merely a question of time. It was as if the pictorial or sculptural composition had become fragmented into its constituent parts, each of which became judged on its own merits. In other words, once the need had been suppressed for representation as a model of fundamental reference, the work of art became introspective and self-referring, that is, it tended to isolate itself from any kind of setting.

Moreover, creativity came to concentrate on what was supposed to be strictly artistic, that is without literary impurities of any kind, and to achieve this turned stubbornly to reductive abstraction. Plastic and visual elements and their relationships were required to be valid in themselves, independently from both their physical and cultural contexts. Consequently, creator and perceiver became alienated from an object that existed in its own right, the otherness of which constituted its most defining characteristic. The advent of Conceptual Art with its crude manifestos of protoconfigurative ideas and the emergence of Minimal Art with its exacerbated formal and material literalness marked the zenith of what we might call objectual, anti-landscape modernity. What happened, nonetheless, is that the very pressures of this radical isolationism practised by the avant-garde led to the erosion of the introspective, solipsist way and the transformation of centripetal into centrifugal force. By following either the conceptual or the minimalist paths, configuration was forced to become dematerialised and dissolved into the chosen objects, into the architectural or natural spaces or into the actions of the creators so that, by virtue of its very inner logic, art returned inevitably to landscape composition. Furthermore, the excesses of reductive abstraction eventually revealed that the metaphorical attributes of objects were interminable, infinite and impossible to extirpate completely. This, on the one hand, resuscitated the metaphysical space and, on the other, denoted the fact that these metaphors were possibly the true abstractions, and not that which lay behind their apparent destruction.

In any case, this inner dynamic was reinforced by the cultural, or rather cognitive, convulsions that occurred simultaneously and pointed in the same direction. Nevertheless, we would do no justice to art history if we lumped all the extraordinary contributions to modern and contemporary art together within the rationalist and idealist avant-garde I have criticised here, for while it is true that modernity perverted its own principles, the fact is that over the almost two hundred years that the modern cycle has lasted so far there have been many creators who with their manifestos, works and extraordinary courage set the self-critical process in motion against the progressive

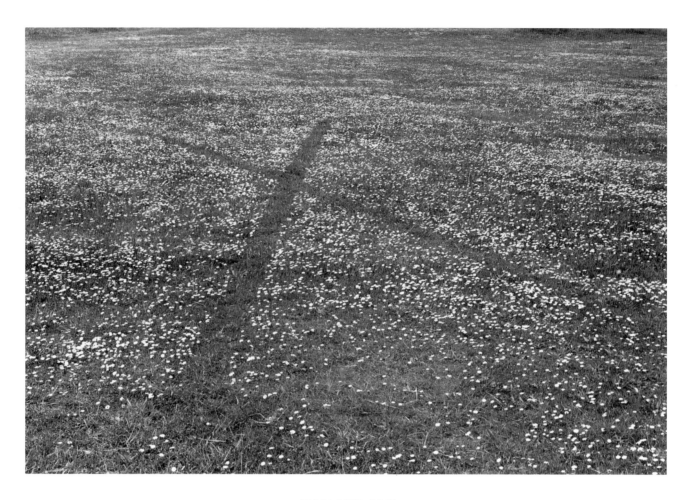

ENGLAND 1968

illuminism that seemed to have monopolised everything. There have always been anti-discursive sparks in the form of individuals or groups who without making ideological concessions keep the embers alive of the poeticisation of reality in its purest sense, despite the fact that much of the so-called historical avant-garde went astray and organised itself into corporate unities so closed that they were unable to detect either reaction or regression. I refer here not to the oneiric landscape art of Surrealism but to other phenomena such as the anti-discursive performances of Dada, to the metaphysical landscape painting of Mondrian, to the suprematist totality of Malevich, and to the spatial explosion of Pollock. In one way or another, those artists (Long among them) who in the mid sixties reacted against the lassitude generated by outright avant-gardism connected with the modern tradition that never renounced either the critical stance regarding all ideologies or the irrepressibly metaphysical essence of art.

As I mentioned earlier, otherness, isolation and supposed plastic and visual purity eventually sought expansion towards space, the subsumption of configuration by actions and appreciation of the objectual galaxy for what it really was, a reality. The dialectic, therefore, was posed in terms of "breaking limits" and, consequently, of landscape. This, however, certainly did not mean a reactionary return to but rather a participation in representation, a critical and poetical interaction with the surroundings, acceptance of the inevitably metaphysical nature of this relationship and, very often, penetration into processes of perception, for while configuration was an interactive phenomenon, perception was not an operation alien to creation but rather an artistic experience in itself. On the other hand, reductive abstraction ceased to make sense as the supreme principle of creativity, since interaction tended towards complexity, not simplicity. Finally, the simultaneity of creation with interpretation and with critical and poetical interaction with materials and objects could only extend the dialectical and consequently metaphysical spaces. Landscape yes, although renewed and extended. Reality too, although to be altered and prolonged, given its mutable nature and given that the creator was at once art and part. Nonetheless, this marked not the end of the modern paradigm but rather its renovation and rescue, to bring it back into line with its initial postulates.

In the same way that the beginnings of modernity in art coincided with the cognitive changes that took place in the XIX century, this qualified return to the landscape principle, which is the end of the most ideological strain of contemporary art during the sixties, had to do not only with aesthetic problems arising from the decline of theoretical fundamentalism but also —inevitably— with major convulsions in the epistemological field that led irremediably to a conception of the real as a complex, unstable global landscape. Obviously, such convulsions in ways of knowing did not occur only in the sixties; they were forged during the two or three preceding decades. Nevertheless, their genesis is such essential fields as philosophy, physics, economics and linguistics gave rise to a domino effect impossible to halt. Concepts such as instability, randomness, vagueness, interdependence and complexity came definitively to affect the foundations of all disciplines. Certainty came to be replaced by probability, while the evolution of complex systems became forever linked to the chaotic processes caused by the ubiquity and intensity of the interdependence of phenomena. The areas of manifest truth in the field of knowledge disappeared, and everything became reduced to an insecure linguistic validation of reality, aggravated by the fact that in the processes of such validation, that which was observed was affected by the configurations and measurements of observers to the extent that occasionally even the direction of causality

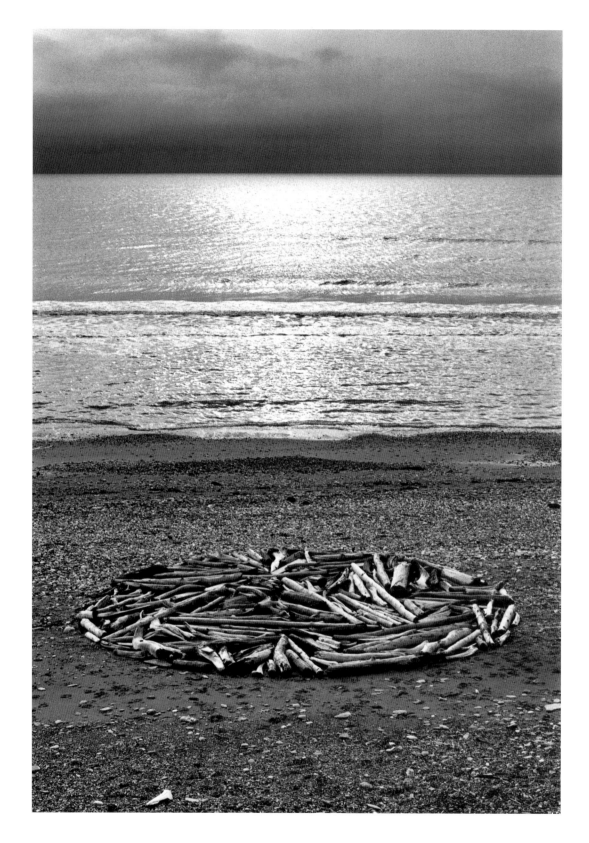

A CIRCLE IN ALASKA

BERING STRAIT DRIFTWOOD ON THE ARTIC CIRCLE
1977

seemed to be reversed. We are in the presence therefore of a conception of the world that can be only global and contingent, like a kind of enormous tautology imbued with variability, that expels partialist and mechanicist focuses when it comes to establishing initial hypotheses. The world, therefore, is a vast landscape in which the empirical and the mental become inevitably entwined. The human being is not a distant observer who configures this landscape; rather he acts on the landscape in an attempt to appreciate, measure and know it. Paradoxically, contingency defines the world, but the individual familiarises himself with it through its transcendental attributes without their being further truths in the exterior. The landscape condition is therefore a transcendental condition or, to put this better, the genuine human condition. It is for this reason that the work of Richard Long has acquired paradigmatic importance in recent art history.

MEASURE, THE WHOLE AND ACTIVE LETHARGY

In the previous section, possibly rather long though, I believe, absolutely necessary, I have attempted to sketch out a suitable theoretical and historical background to the work of Richard Long by virtue of its paradigmatic character and of the purity that invariably typifies its elaboration. I have pointed out how in the second half of the sixties a return was made to the idea of the premodern landscape whole as an essential configurative concept, making it clear that this return had been fostered neither by the principle of representation nor by theological restrictions but by the evident interdependence between structures that, for beings and for objects, modernity had obstinately insisted on isolating. On the other hand, one particular aspect of this return was that it placed the human being on the only throne due to him, that of the reflexive observer whose nature was reflected in the global landscape in the same way that that one was the reflection of this one; inasmuch as every observation depends on the prior configurations of the person who observes, since there is nothing outside of experience and, in turn, we perceive in a specific way because the universe, that is the whole, has imposed a concrete evolution on us. During this period, therefore, the total, circular characteristic was established of appreciation of reality, a kind of huge, complex, unstable loop to which nothing is alien, not even perceivers. Consequently, access to knowledge and to creation could be contemplated only from inside the landscape whole by altering, expanding and transforming it. Furthermore, it was not a strictly physical landscape, for in its core language, information, matter and objects are inextricably mixed and stratify their mutual influence. This mixed

essence converted the landscape into a great metaphor impregnated by the transcendent, metaphysical self that defines us all, independently of the existence or non-existence of a creator.

Nonetheless, of all the aesthetic components of this renewed landscape art that emerged at the end of the sixties, it is probably the assessment of configuration and measure as essential, unavoidable human attributes parallel to all forms of knowledge that is probably the most difficult to establish. In the first place this difficulty stems undoubtedly its theoretical delimitation, since it might be more appropriate to speak of premises or compositional condition —as I have done on other occasions— rather than to group together more generic terms such as configuration, observation or measure. This substitution certainly makes sense, for the revaluation of the configuring role runs parallel to the recuperation of the landscape and both share a markedly pictorial character in that they continue the great tradition of art. This seems somewhat contradictory since, as I said at the beginning, the aesthetic convulsions of the late sixties have much to do with the work of art's breaking out from the confines of a separate, self-sufficient object and, by extension, also out from the picture frame. I must stress, however, that this penetration of limits and this expansion of works towards the landscape are tinged with painterliness, with everything this implies in terms of formalisation and composition, even though they might refer to a painting that has no frame and whose creator is inside.

Secondly, just as the landscape was not only an unavoidable (let us say technical) motif, having become the only coherent reference, but also a nodular metaphysical crucible, a provider of an infinite number of metaphors, and consequently of endless abstractions. Composition, with its measurements and spatial arrangements and due to its special quality as a supreme attribute of existence, had also come to constitute a primordial sign of transcendence and, more specifically, of the tragic sense of the human drama. Indeed, it is in dialectics that is set up between the changing whole that contains beings and the innate zeal of beings to capture the regularities —which though never absolute seem to govern reality— from which all dramas and all joys emanate and, by extension, the tragedy, the humour and the irony that constitute the ferment of all genuine art. It might even be no exaggeration to say that the evolution of man, with his successes and failures, and the different fortunes that social groups have harvested throughout the history of cultures have depended, and still largely depend, on the individual and collective abilities to manage this complicated dialectics. This means that both in concrete works and in the creative approaches underlying them, what I

call the compositional condition may be present as a specific formalisation or as a symbolic reference, or as both things at once, so that the emphasis on this condition may be difficult to grasp.

Thirdly, and finally, all artists accustomed to those turbulent days were driven by their intuition and by their feelings towards landscape expansion, although we must not overlook the context on which these drives depended to a greater or lesser extent. Those were the years of outright avant-gardism and of innovation for innovation's sake, in which young artists, having found support in the indelible traces of the historical avant-garde and almost drunk with power ran the risk of becoming bourgeois and corporatist *enfants terribles*. To come out from under the prejudices and conditioning factors of this kind of modern fundamentalism was no easy task, and many creators failed to do so, perpetuating their "tics" ad infinitum. Those who succeeded, however, embarked on a kind of return to their origins or, to put this another way, started from a radical scratch that stressed the most experimental aspects of artistic creation unfettered by any kind of technical or ideological restrictions. In this sense, the case of Richard Long is especially illustrative, since after having left the East England Art School he and his strong, independent personality ended up at the Saint Martin Art School, where he became an emblematic figure of the new creative strand. What is Art? What is its function? How may this idea be formalised? What part of my privacy should be transferred to audiences through my works? These and other radical questions were once again openly asked with crude ingenuousness. Although strongly imbued with compositional intentionality, this primitive dynamic seemed nonetheless to hide or even reject it, for procedures continued to be as anti-academic as they had been in the heroic times of the historical avant-garde. Moreover, initially artists' actions on their own bodies and their performances in different spaces were met with mistaken critical appraisals that stressed their theatrical quality and, in general, the confusion of genres. The actions corresponded in fact to a radical rejection of the otherness of the work of art and of its specialised world, from which artists sought to escape, and an operation through which to test the imprecise limits between the public and the private. In addition, we should not overlook two key aspects implicit in open, interactive landscape art: one, that interaction means the specific participation of the creator in compositional approaches, which provides artists' actions with a wider scope than that of the mere vindicative strategy I have just mentioned; and two, that the revaluation of the configuring role of human beings establishes corporeity as a fundamental compositional tool with which to imbricate oneself into an unlimited landscape.

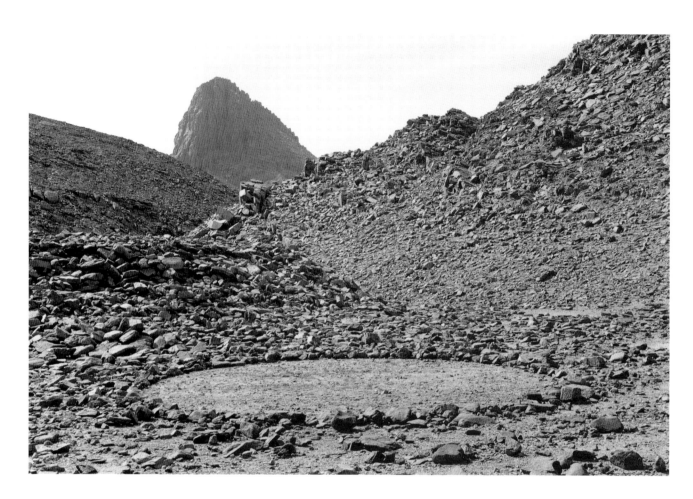

HOGGAR CIRCLE

THE SAHARA 1988

Inevitably, when several levels of expression are activated the compositional con-
dition may witness its importance diminish, but there are creators who are aware of
this risk and never cease to stress its relevance. One of these is Jannis Kounellis, with
his omnipresent steel drawing panels; for his part, Richard Long has already left to half
the world his circles and linear paths as primordial signs of formalisation and measure.
He made he following comment regarding this to Richard Cork: "(...) it's like a balance,
a harmony between complementary ideas. It could be said that my work consists of a
balance between the forms of nature and the formalism of human abstract ideas, such
as lines and circles. This is where my human characteristics meet the natural forces and
the forms of the world, and this is really the subject of my work".[1]

I have no doubt whatsoever that Richard Long agrees with me when I split the sixties into two, assign to the second half an eminently landscape character in artistic terms and include him in it. In Anne Seymour's[2] well-known seminal essay there is an essential quote from Long on the question: "Halfway through the sixties, the language and intentionality of art had to be renewed. I felt that art had scarcely recognised the natural landscapes that cover this planet, nor had it undergone the experiences these places offer. Starting out from my own threshold and stretching myself later, part of my subsequent work has been an attempt to exploit this potential." What has never ceased (nor will ever cease) to astonish me, however, is the honesty and totality with which Long undertook this task, which still continues. When I say totality, I refer specifically to the identity between attitude, action and the rules of life. Long appears to audiences and critics as a compact, serene being, not on the other hand lacking a simple, intelligent, biting sense of humour but apparently immune to vehemence and all empty discourses. Feared by many and yet attractive to others, by virtue precisely of his almost insulting authenticity, his profile can be interpreted in two ways. On the one hand, he appears as the archetypal Briton, with the gift of word play though incapable of double talk; sincere and far removed from any discursive rhetoric, although when he stresses the obvious he is aware that behind this are hidden multiple interpretations and emotions; sparing in gesture and in the expression of his emotions, although extremely sensitive and capable of going into raptures over the grandeur of his perceptions. On the other hand, however, such Anglo-Saxon purity, with an undoubted bias towards the romantic, is combined with almost ascetic militancy and determination when it comes to carrying out his demanding aesthetic premises, so that Long's relationship with the world, both as an artist and as a man, is like a placid accompaniment, without traumas, owing a debt only to love and to the poetry of things and phenomena. Hence the fact that his creative approach has often been compared to the Zen variant of Buddhism. Furthermore, Anne Seymour's excellent article openly responds both in title and structure to this affinity with Zen. For his part, Long declares himself to be ignorant of this doctrine and alien to any oriental influence that is not a pure coincidence; nevertheless, I can only concur with Seymour in that there are point of intense contact with Buddhism in general and with Zen in particular. Regarding this, I sincerely believe that Long's is one more case among many of convergence between oriental and western cultures within a global context of coincidence that has been widespread since the XIX century. What occurs with both the work and the personality of Richard Long is that they convert the similarity into a certainty difficult to refute, by virtue of its clarity and concision. Indeed, we need only review the principles of the landscape art recovered in the sixties to see that they contain major oriental, and above all Buddhist, connota-

tions. Thus we might mention the causal link between all structures; the absence of teleology; the contingency of language; the uncertain, mutable whole; interaction as a creative process and, above all, the metaphysical characteristic that impregnates interactions due to the transcendent nature of the processes of knowledge of reality. Nevertheless, it must be understood that this set of cognitive tools is not fruit of mystical meditation, as it is in oriental cultures, but of a critique of ways of knowing that modernity itself has created as a result of the contrast between the different conceptual frameworks that represent the world and the events that confirm its daily evolution. Consequently, these tools are firmly based on the scientific, mathematical and philosophical traditions of western culture. It would be expedient here to recall Spinoza, for example, who on a basis both mathematical and mystical broke away from Descartes' dualism to bring together thought and extension in one single concept; that is, he con-

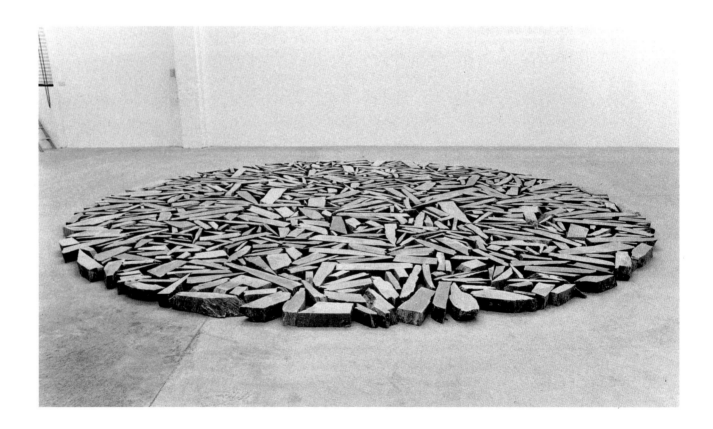

HALIFAX CIRCLE

DEAN CLOUGH
HALIFAX 1989

ceived the perfect union of matter and ideas in a complete, interrelated and pantheist whole that left no room for teleology. In the same order of considerations, it would be indispensable to mention the enormous contribution by Schopenhauer, who was interested in though not influenced by Oriental philosophy. Indeed, Schopenhauer freed Kant from his moral prejudices and took transcendental idealism to the extreme of its explicative possibilities to constitute a complete, compact system, without any kind of theological restriction. With the weight of certainty he defined a blind, autonomous universe, defined by movement, desire and causality, whose true nature was accessible only to the appearance of our representations. From all this he deduced also that in order for our relationship with the world to be coherent, it needs a metaphysical and moral basis. These two figures —Spinoza, practically at the beginning of modern western philosophy, and Schopenhauer, at what was probably its most brilliant and definitive moment— are landmarks in the intellectual convergence with the East, although evidently, however ideal they may be for my purposes here, they are certainly not the only cases. Finally, during the XX century science came to sanction with pristine evidence the accuracy of the conclusions the two cultural strands of philosophical speculation had reached, albeit along different paths. It is consequently only logical that the recovery of landscape art to which Richard Long has contributed should belong to this convergence, as does any cultured person from his time and cultural origins.

There is a great variety of schools of thought in Buddhism, although very generally speaking the Buddhist concept of the world supposes an infinite number of phenomena interconnected by complex processes and does not presuppose the existence of any creator to dictate them. Furthermore, it tells us that we can accede only relatively to an understanding of the nature of things, for the observer actively intervenes in the construction of perceived reality; consequently the worlds of science and the spirit cannot be at odds with each other, but quite the contrary. It is therefore clear what the global nexus of convergence is that I am describing here, although it is also true that on such a generic level the orientalist connection is important not only for Richard Long but also for many of his contemporaries. If in his case this ubiquitous similarity, above all if we reduce the comparison to Zen, can be particularly stressed, it is because it extends particularly intensely to the ambits of attitudes and dispositions. In this sense, we would be tempted to think that like just another young man of his generation he would have felt the impact of Alan W. Watts' dissemination of Zen doctrine in the sixties or would have undergone some kind of cultural shock during a pilgrimage to or stay in India, so much in vogue at the time, although I have come across no evidence of either. Rather, such intensity is fruit of having carried with extreme

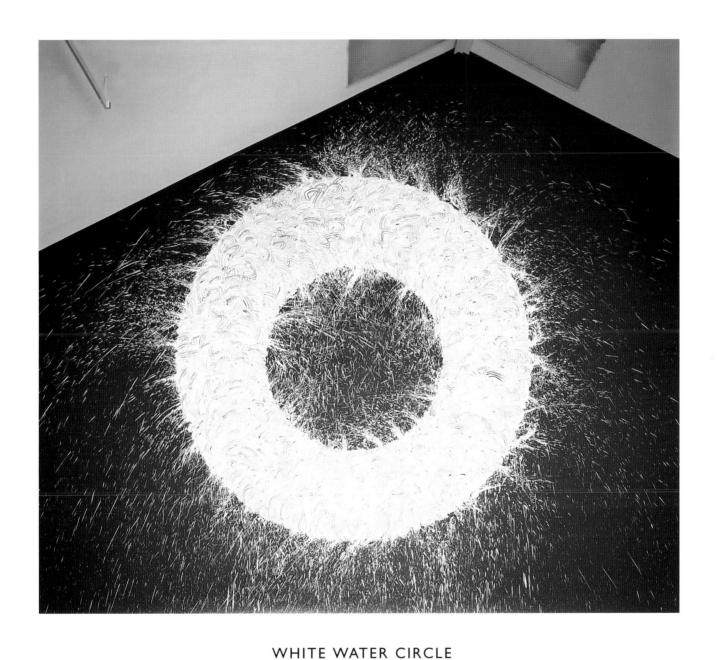

WHITE WATER CIRCLE

GALERIA WEBER ALEXANDER Y COBO
MADRID 1990

rigour the parameters that govern his creative approach to their ultimate consequences. If there is one concept that defines Zen more than any other, it is spontaneity,[3] in the sense of numbing intention, analysis and even reflection. Of course, this has to do with the Buddhist premise according to which desire makes us prisoners of suffering, but for the followers of Zen this sublimation of spontaneity implies a proposal that is neither dramatic nor mortifying, as it would be in other Buddhist strands: it is based simply on the idea of dodging or ignoring passions rather than stubbornly challenging them. Although this may seem a difficult exercise, it is possible if one allows the mind to flow freely, embracing the grandeur of everyday details and potentiating the peripheral, intuitive perception of things and phenomena, beyond language and its betrayals. Nonetheless, says Zen, this can be achieved neither by separating our self from experience nor by considering existence as the consequence of thought but by remaining awake as we evolve alongside things, seeking encounters rather than attainments and valuing the circumstances of our present rather than the future. In other words, it is a question of psychosomatically feeling our communion with nature and leaving the dynamics of our intellect free as this occurs, rather than of articulating our experience with rigid discourses. In this sense, Watts offers the following parody of the western obsession with mental control: "(...) not content with savouring the meal, I try also to savour my tongue. Not content with feeling happy, I want to feel myself feeling happy, to be sure I'm not missing anything".[4]

In the strictly aesthetic sense the Zen way once again advocates naturalness, since all works of art inevitably form part of nature in that configurative techniques are synonymous not with artificiality but with alliance, by virtue of their main purposes of induction and control of accidents that take place unexpectedly. Indeed, human beings' interference with nature is defined precisely by this cognitive characteristic of configurative control, since we are not superimposed on nature but rather flow inevitably in its company. Consequently, chance is the crucible of all our creations, inevitably interactive, in turn, with their environment. The works and life of Long seem thoroughly to be in accordance with the spontaneity that defines Zen, and just as many Westerners consider this doctrine to be crammed with ingenuous passivity and lazy absenteeism, Richard long's creative approach is in the opinion of some characterised by almost insulting renunciation and by a casualness bordering on arrogance. Nevertheless, I firmly believe that this kind of waking, sensitive surrender to the arms of multiform evolution, the best definition of which is the contradictory one of "active lethargy", is also the only one consistent with the totality, the relativity and the instability of the landscape in which we are immersed and which the creators of the late sixties recog-

nised, for, among other things, only from a serene, distant position is the authenticity of our experiences possible. Richard Long is a staunch practiser of this lethargy, but not the only one, since many other creators with this attitude have preceded him this century and many accompany him today. Active lethargy, far from being abandon, is a strategy of freedom and a denouncement of non-existent aims, with all the force implied in its assumed ingenuousness.

PATHS AND MARKS

Elsewhere in the text, where I sketched Long's British characteristics, I underlined a romantic trait, which when I subsequently commented on Oriental parallels would seem to be contradictory due to the rather trite ideas of despair, anguish and rejection associated with the archetypal romantic artist. Nevertheless, it should not be forgotten that extreme religiousness, sublime individualism, disdainful voyeurism, the anti-discursive surrender to nature and the exaltation of innocence are also defining —and more generic— characteristics of Romanticism. We might easily find similarities, one by one, between these romantic keys and fundamental aspects of Long's creative approach, duly nuanced by the artist's serenity and economy of both plastic and visual expression. He certainly does not appear to be (nor is he) a suffering artist, although there is always an element of suffering in creation, and his deliberately contained gestures are habitually minimal. By contrast his work, either as a whole or as individual pieces, can be cutting and even caustic. I believe there is much religious reverence in his solitary immersion in nature, much disdain, criticism and playfulness also in the effective innocence of his geometrical counterpoints. On the other hand, neither Richard Long nor a host of other protagonists of the sixties' split abandoned the modernity of which Romanticism was the explosive generator; on the contrary, they revised it from within, that is, from its own premises, in an attempt to eliminate rationalist fundamentalism. Furthermore, it is very difficult to find in them even a hint of aggression against the tradition of the historical avant-garde, which in fact, and by virtue of their deep respect for it, they attempted to rescue from its own mistakes. In another context, C.D. Friedrich never ceased either to compare art with children or to insist on the fact that the true source of inspiration was a pure, infantile language. He also said that art was the mediator between man and nature and that, consequently, a painting was not an invention but proof.[5] For his part, Richard Long recognises that the physical reality of his walks generates his configurative ideas and that this is the best evidence of the concept of realism he professes with devotion. Similarly, he refuses to separate infancy from adulthood

and never ceases to congratulate himself when critics compare his works to simple children's games, like throwing stones into a river, for this is precisely what they are.

If I have just mentioned Long's respectful attitude to modernity, this is because though sparing in its expressive elements, his work nonetheless forms a synthesis with the artistic sources from which it drinks. When he categorically assures us that his works are concrete facts with no representational aim, because this would be art history and not art, this does not mean that they do not contain, as strata, the creative approaches that most influenced him in his formative period. Indeed, as befitting an interactive landscape painter, Long is inside representation, in other words, he does not subsequently duplicate that first representation the intellect makes of what is perceived. On the other hand, however, in his works action, idea and form come inseparably together on a level of extraordinary purity, so that they would satisfy the most stringent theorists of Minimalism, Performance Art or Conceptual Art. These aesthetic traces, more than reminiscences of long abandoned practises, denote a clear, unequivocal creative stance, a recognition on the one hand of the achievements of creative strands that managed to break down the configurating drive into its simplest elements and exorcised all forms of compositional confusion and, on the other, rejected both the isolation of the work from its surroundings and its self-referring otherness, while preserving the metaphorical potency of signs.

Going now more into details, I believe we can unhesitatingly state that the creative drive emerges in Richard Long from action and its continuity, as befitting the state of constant vigilance a genuine active lethargic maintains. This means that, in his case, we have to obviate the idea of will or volition as such, in the style of Picasso's well-known configurative voracity, for example, since I believe Richard Long is the exact antithesis of this kind of ambition. Rather, his creative disposition recalls the jealously kept distance of Musil's Man without Attributes or the almost insulting quietism of Duchamp who, when asked about his activity, like to reply that he was breathing and that his faithful companion, Rrose Selavy, was expectant, as if crouching. This does not mean that there is no intention, but as I said earlier in attempting to fit Long's stance into Zen philosophy, the drive emerges accidentally from a situation of accompaniment and interrelation between the creator and the landscape in which he stands, which as such is not proto-plastic but a work in its own right. This question is far from a trivial one; it is a central aspect of contemporary creation, since disregard of desire as a separate category belonging to the subject —and the latter's fundamental weapon when it comes to relating to objects, provided this desire refers

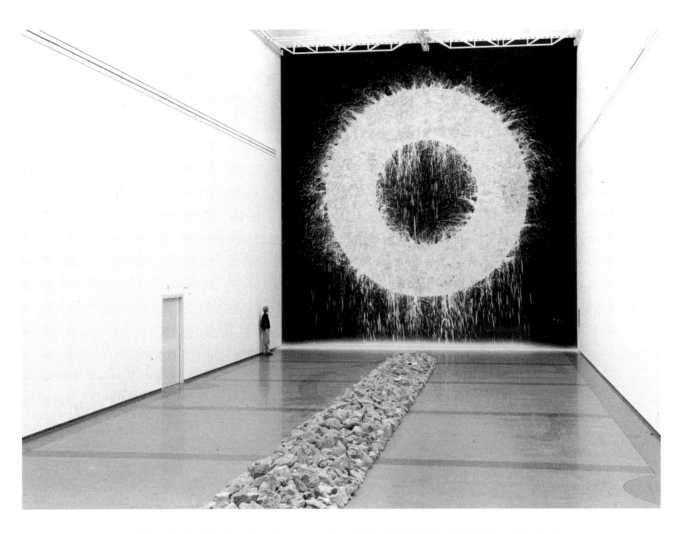

NEANDERTHAL LINE (detail) AND WHITE WATER CIRCLE
KUNSTSAMMLUNG NORDRHEIN-WESTFALEN
DÜSSELDORF 1994

exclusively to the aggressive survival instinct and all its anthropological and psycho-
logical derivations– is the only attitude consistent with the concept of the world we
may have today. Although I did not particularly stress this earlier, this is also an essen-
tial point of convergence between contemporary oriental and occidental cultures and
a further consequence of the logic of interactive landscape art. In all interactive cre-
ation that takes place in a mutable container of indefinite confines, actions and deci-
sions are simultaneous by definition. But besides the absence of prior phases or states
of volition –and leaving aside the special relationship we have with our own bodies–
we can interact with our surroundings in only two strictly human ways, in the sense

that they have to do with our spirit and do not fall within the category of what we might call biological or natural will (desire). I refer to doing good and creating, precisely because they lie outside the blind rule of survival, which is the breath of the universal even for inorganic matter, since they obey not this aim but their own essence. If there is no specific aim, there is no specific desire, but rather irrepressible decisions and intentions that emerge from indulgence of the spirit, when psychosomatically we feel the emotion produced by the exercise of good or participation in the indeterminist process of creation that is nature. As I said, then, in Richard Long action and its continuity, or more specifically his strenuous efforts as a walker or the mere prospect of reincarnating them at any time are already works in themselves. I am talking not about short strolls but walks of dozens of miles lasting several days through meadows, over mountains and across deserts, under all kinds of weather conditions and in any part of the globe. Nonetheless, his walking is solitary, like the ecstasy of the climber who reaches the summit or the tingling emotions of the monk on the beach in C.D. Friedrich's paintings since, as he says, this is a strictly private operation and the importance it may subsequently have makes no difference. Sometimes, when these excursions take place in Europe, Long plans his itineraries with considerable precision, as would a geographer; on other occasions, however, circumstances accidentally map out the route, as in the Sahara, where the pools left behind by storms fixed his comings and goings like landmarks. The how, when and where of his material interventions (when they take place, since the very itineraries themselves are sometimes form) tend to be accidental and the fruit of pure intuition, as befitting an interactive process. Long says that it is hardly a decision; he simply gets the feeling that there is where he must shape his idea and, also by chance, the formation of signs is made possible by the proximity of lava fields or other residual decantings of nature. The place, the itinerary and the moment are thus inextricably linked; consequently, the motif for shaping can hardly stem from displeasure. Quite the contrary, in the words of the artist himself, it is a celebration. Does this mean that the stone spirals or the trodden paths are a monument, the sign of an event remembered on its anniversary? In part yes and in part no; although I should qualify this answer since it enters a territory of considerable critical controversy, in that prestigious art theorists have accused contemporary sculpture of having lost its way once it became freed from its servitude to the discourse of power and consequently ceased to be a mere architectural and urbanistic embellishment, above all in terms of sites. Regarding this question, for me there is no such failure and even less a possible subsequent subordination to painting. The dialectics between painting and sculpture marked the phase of objectuality and self-reference that prevailed in art until the mid sixties, without either clearly

predominating over the other. Later, back together again, the two genres were equal protagonists in the breaking of confines resulting from the artistic renovation of composition according to landscape criteria. Long is a shining example of the recovery of the importance of place, although this time without discursive crutches; and also of the delimitation of the ambit to which all celebration of events should be restricted, that of the celebration of interactive creativity or, which is the same thing, of the perception of the universal essence of all things and all circumstances. Coming back to details, it is necessary to stress however that Long practically never has recourse to verticality, the monumental sign par excellence; quite the contrary, his elementary forms underline horizontality and its plastic integration with the terrain, so that the celebration points accurately towards union with the landscape, more than anything else.

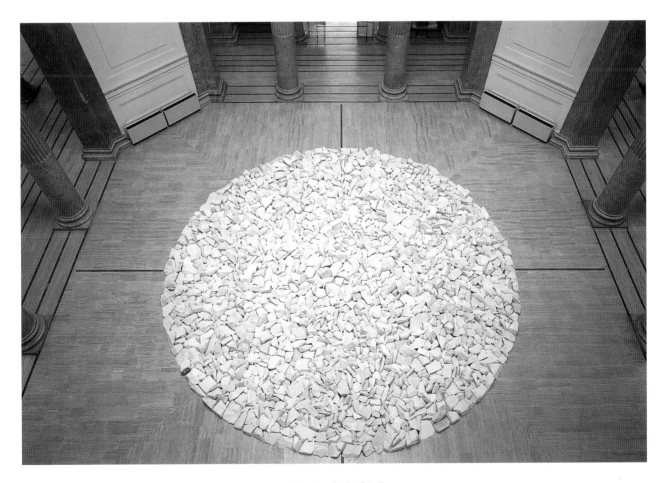

ROME CIRCLE

PALAZZO DELLE ESPOSIZIONI
ROME 1994

I have equated the evolution of action, that is, its process, with form and site when it comes to judging the compositional elements that Richard Long manipulates, which means the dimensional inclusion of time (the subject of one of his projects as a student was the Theory of Relativity), but there are a couple of additional plastic aspects that must not be overlooked, in parity of conditions with all the rest. I refer to tactility and corporeality, both directly related to the great tradition of sculpture and which with the usual sublimation of conceptualism tend to be either overlooked or played down. It must not be forgotten that an aesthetic characteristic of the generation of artists from the second half of the sixties is the valuation of the intrinsic and extrinsic characteristics of materials, making no distinctions whatsoever in terms either of origin or quality. By intrinsic we mean the most sensitive attributes, and consequently the most abstract from the point of view of perception; the extrinsic qualities, on the other hand, are the inextricable linguistic adherences that convert them into metaphors to be used at the perceiver's discretion. Long, by dauntlessly pursuing the identification of the idea with perception and form, while shunning all compositional complexity and stringently restricting his selection of materials to what nature offers him, is compelled deliberately to reduce the material and objectual galaxy on which he poeticises. Nonetheless, it is enough to attend his exhibitions in interiors to realise the importance he assigns to the "mordant" of matter when it is duly articulated by configuration. If the true or implicit tactility of materials makes them organic, when they are not, through perceptive processes, all configuration, when perceived or carried out, is inextricably related to our bodies through necessity and through logic, regardless of academic axioms. This natural corporeal nature of configurative action is moreover reinforced by its own purity, since nobody needs either language or erudition to come to an understanding with their body, and nobody can avoid the notion of their corporeal dimensions when they measure and delimit spaces in their compositions while they interact with the landscape. For any genuine creator, these questions are obvious; in the case of Richard Long, however, by virtue either of his almost initiatory walking, or of the manual way in which he likes to shape his simple, expressive forms, or of the meaning acquired in his works by the re-creation of the compositional premise (or condition) that defines us all, the body constitutes a reference as beloved as it is unavoidable.

Formalised in negative, by eliminating residues from the land, or in positive, by carefully piling them up, Richard Long's forms, which are sometimes also shaped by footprints on the grass, are drawings that prolong his body and mark the paths

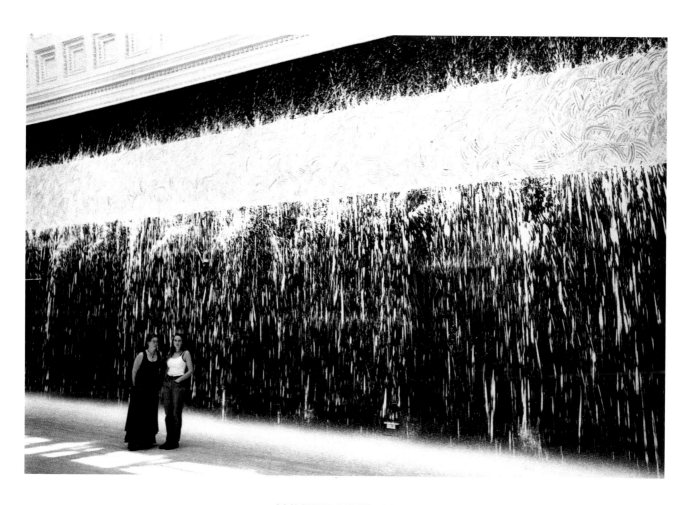

WHITE MUD LINE

PALAZZO DELLE ESPOSIZIONI
ROME 1994

defined by his ceaseless walking. Extreme forms of abstraction, these signs contain all metaphors inside their dense archetypal thickness, among them that of our existence through its interactive and configurative essence allied with the landscape, far removed from any alienating virtuality and close to the spiritual root of all experiences. When Long transfers these signs to his compositions in interiors, the alliance with closed spaces is as close as it is exquisite, the material quality of lime, coal, limestone or clay is emphasised to the point of sublimity and universal forms are converted into a primordial nexus with nature, without even a hint of Platonising intellectualism. The natural and interior spaces, however, are not the only ambits of plastic

intervention that Long uses. There are works that, though by comparison almost poor, are of a delicacy from which explosive poetry spreads. Simple maps drawn with the forms of itineraries, including short deviations or possible momentary disorientations. There are visual poems that are pure conception, in which the arrows indicating the wind direction or the phrases that describe chance encounters with the details of the landscape configure the usual recurring forms. Paths and marks; life, knowledge and experience; with everything and against nothing; without wanting to and yet doing... in silence. I was with him in Huesca, accompanying him during his creative stay. It was then that I learnt of his serenity and enthusiasm. Everything was simple and spontaneous. Everything was truth.

[1] Interview with Richard Cork in *Richard Long. Walking in Circles, Hayward Gallery,* The South Bank Centre, London, 1991.

[2] A. Seymour, "El estanque de Bash - Una nueva perspectiva", in *Piedras. Richard Long,* Ministerio de Cultura; The British Council, Madrid, 1986.

[3] A.W. Watts, *The Way of Zen,* Pantheon, New York, 1957.

[4] A.W. Watts, *op. cit.,* p. 170.

[5] Carus, C.G. and Friedrich, C.D., *De la peinture de paysage dans l'Allemagne romantique,* p.167, Klincksieck, Paris, 1983.

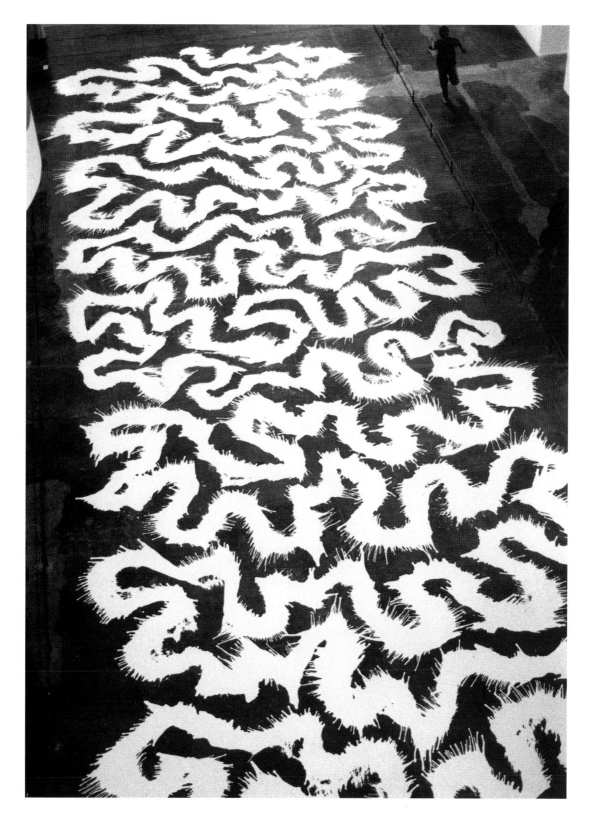

WHITE RIVER LINE

SÃO PAULO BIENAL
BRAZIL 1994

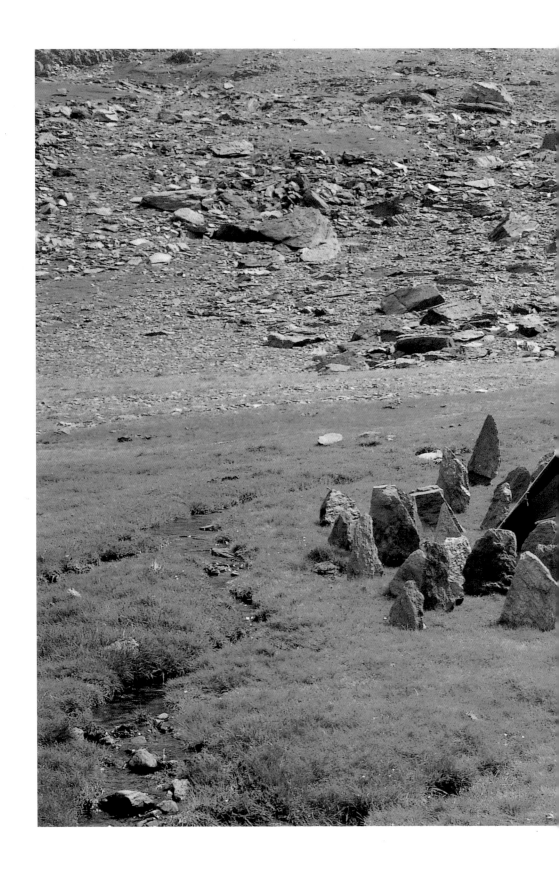

CAMP-SITE STONES

SIERRA NEVADA
SPAIN 1985

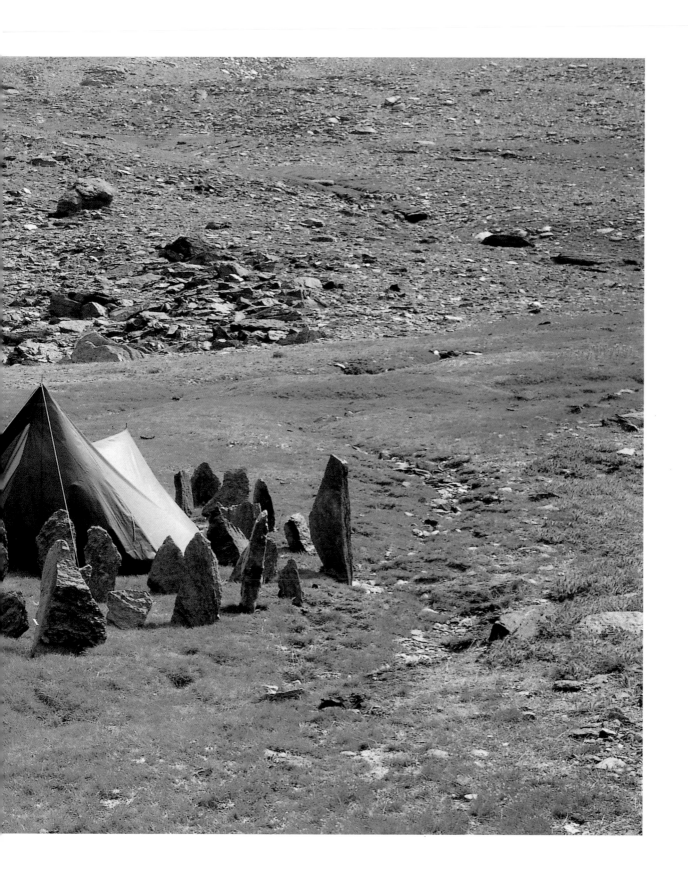

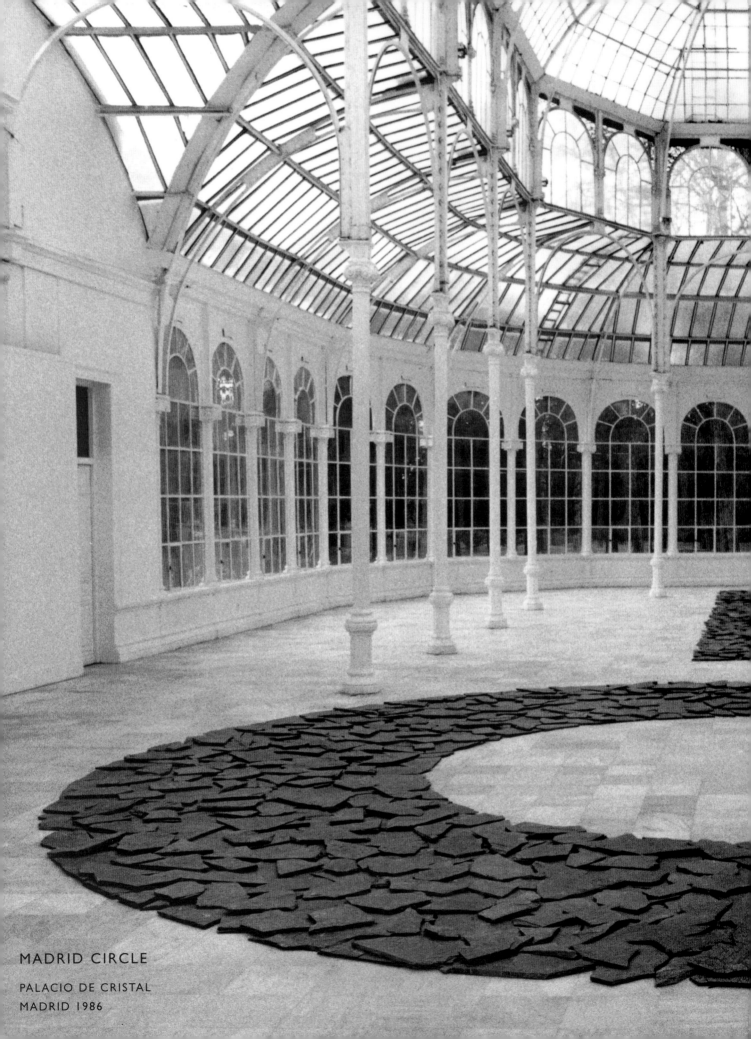

MADRID CIRCLE

PALACIO DE CRISTAL
MADRID 1986

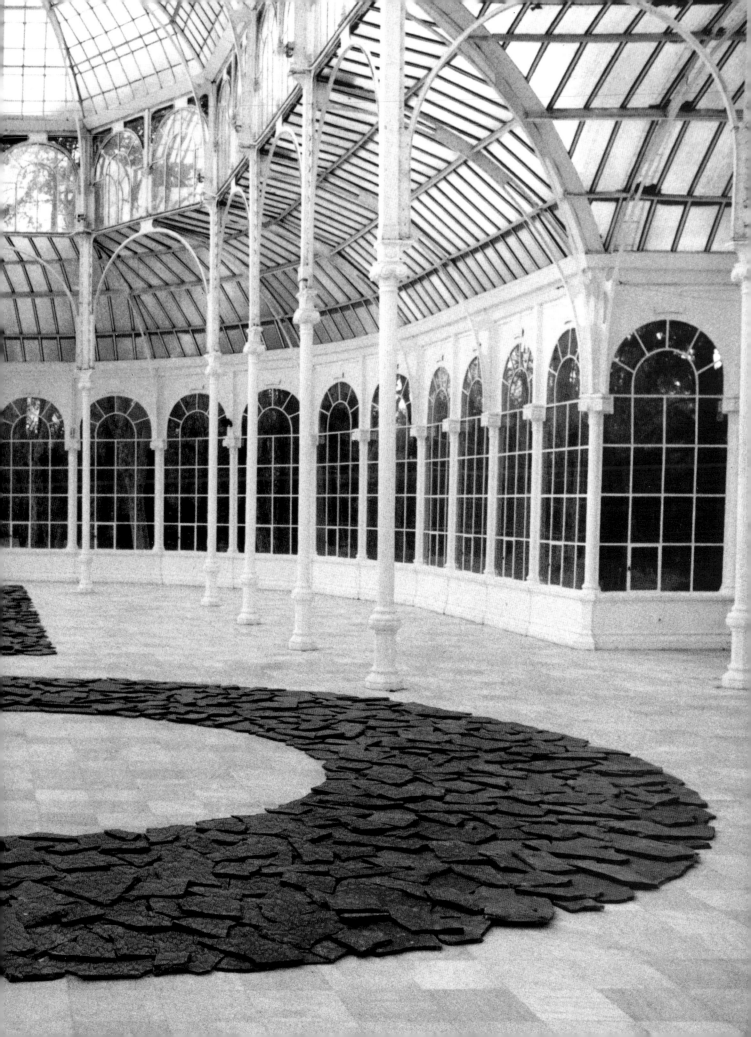

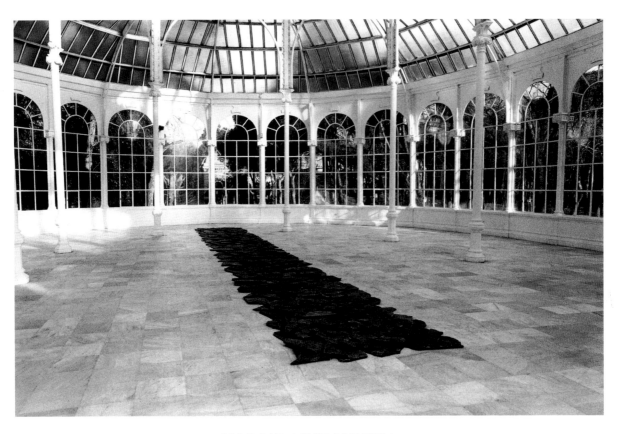

MADRID LINE NORTH

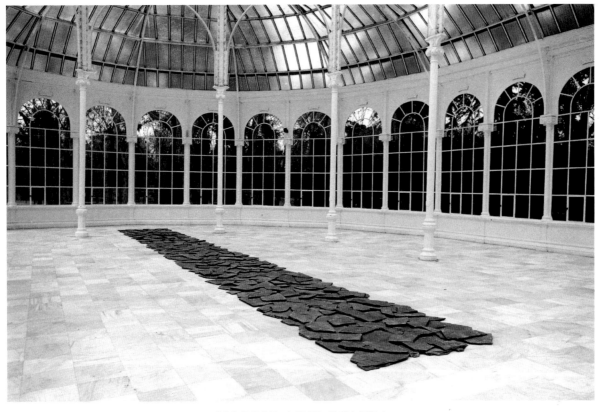

MADRID LINE SOUTH

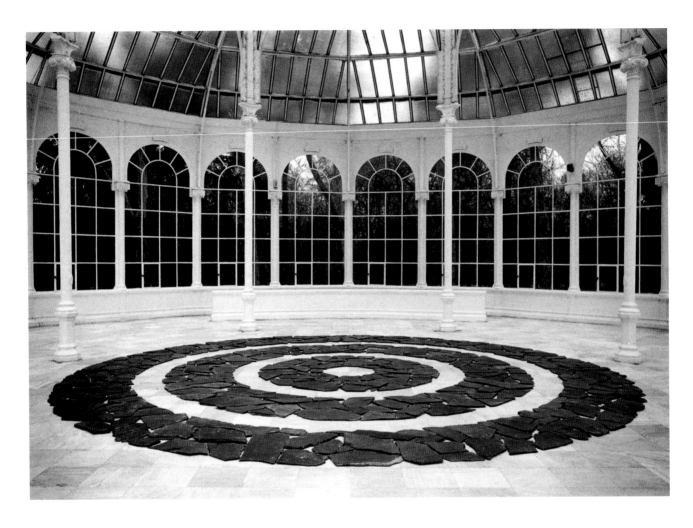

SEGOVIA CIRCLES

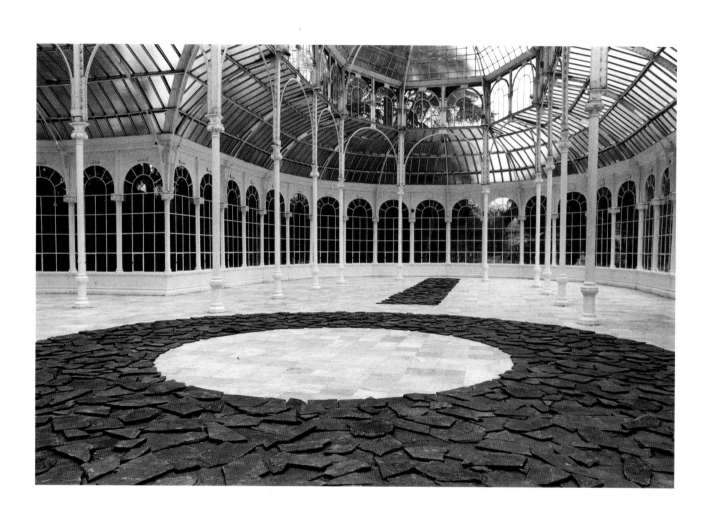

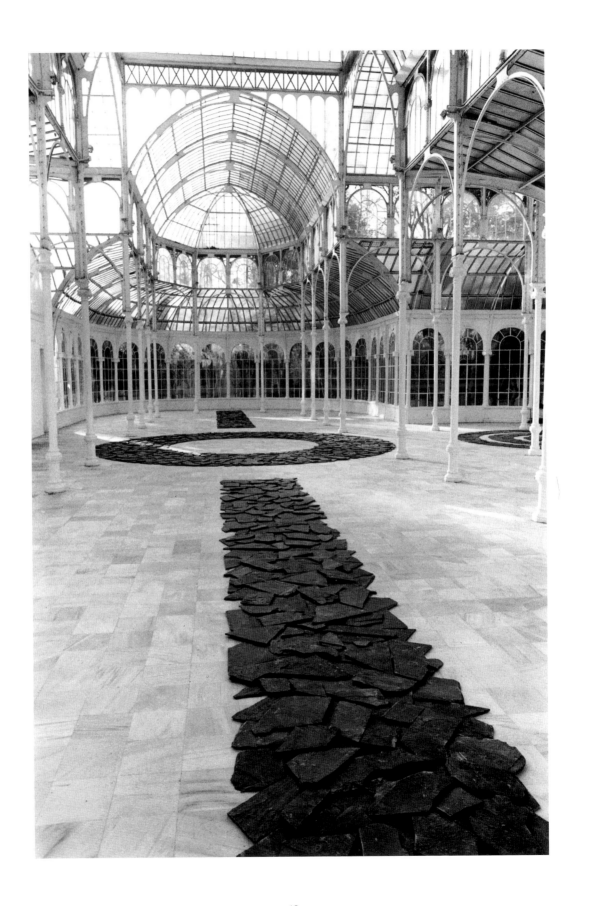

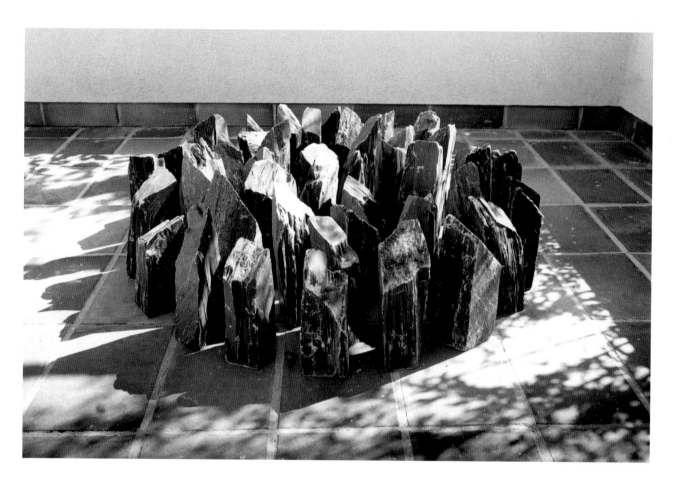

SMALL SEGOVIA CIRCLE
MADRID 1986

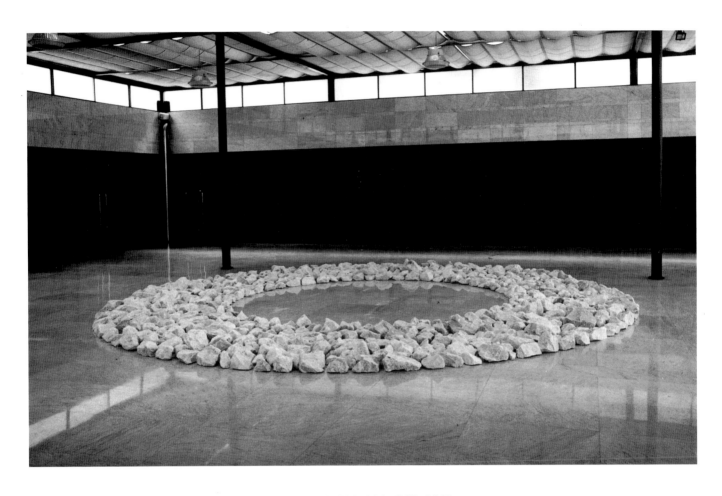

CATALAN CIRCLE
BARCELONA 1986

A CAIRN NEAR ERLETXE

A CAIRN NEAR MAEZTU

A CAIRN NEAR LARRAGA

SPANISH STONES

A COAST TO COAST WALK OF 410 MILES IN FOURTEEN DAYS
FROM THE BAY OF BISCAY TO THE MEDITERRANEAN
MAKING CAIRNS OF WAYSIDE STONES ALONG THE WAY

EUZKADI TO CATALUNYA

1988

A CAIRN NEAR SADABA

A CAIRN NEAR ALBELDA

A CAIRN NEAR TRAMACED

A CAIRN NEAR EL TARRÒS

A CAIRN NEAR LAS PEDROSAS

A CAIRN NEAR ELS CASSOTS

A CAIRN NEAR CANTALLOPS

A CAIRN NEAR GAVÀ

WATERLINES

EACH DAY A WATERLINE
POURED FROM MY WATER BOTTLE
ALONG THE WALKING LINE

FROM THE ATLANTIC SHORE TO THE MEDITERRANEAN SHORE
A 560 MILE WALK IN 20½ DAYS ACROSS PORTUGAL AND SPAIN

1989

WIND LINE

A WIND DIRECTION EACH DAY
ALONG A 560 MILE WALK IN 20$\frac{1}{2}$ DAYS
FROM THE ATLANTIC COAST TO THE MEDITERRANEAN COAST

PORTUGAL AND SPAIN 1989

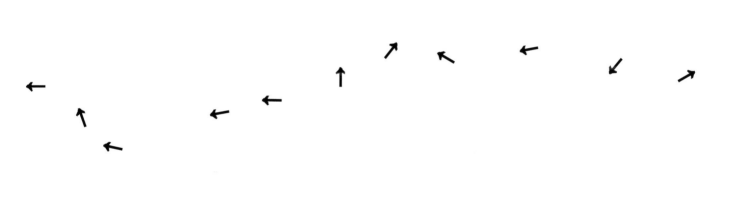

SOUND LINE

A SOUND FROM EACH DAY
ALONG A WALK OF 622 MILES IN 21 DAYS
FROM THE NORTH COAST TO THE SOUTH COAST OF SPAIN

1990

SURF ROAR AT RIBADESELLA

A THUNDERING RIVER IN THE DESFILADERO DE LOS BEYOS

A MEWING BUZZARD NEAR HORCADAS

A SQUEALING PIG IN SAELICES DEL RIO
A BARKING DOG IN SAHAGÚN

A SKYLARK NEAR MORAL DE LA REINA

GEESE NEAR MEDINA DEL CAMPO
STARLINGS IN FUENTE EL SOL

A SPLASH IN A RAIN PUDDLE IN MIRUEÑA DE LOS INFANZONES

CRUNCHING SNOW ON THE PUERTO DE LAS FUENTES

A BRAYING DONKEY NEAR SEGURILLA

KICKING A STONE IN ALCAUDETE DE LA JARA
HISSING WIND THROUGH BRANCHES IN LA NAVA DE RICOMALILLO

A COCK CROWING NEAR HERRERA DEL DUQUE

A FROG NEAR ALMADÉN
THE SCREECH OF A HERON ON THE RIO VALDEAZOGUES

HITTING TWO STONES TOGETHER IN VILLANUEVA DE CÓRDOBA

A FLOCK OF CROWS NEAR ADAMUZ

A BARKING DOG IN SANTA CRUZ

CRACKLING FIRES NEAR MORILES

WHISTLING OVER THE RIO GUADALHORCE

SURF ROAR AT MÁLAGA

IN THE MIDDLE OF THE ROAD

HALFWAY STONE

IN THE MIDDLE OF THE WALK

A ROAD WALK OF 622 MILES IN 21 DAYS
FROM THE NORTH COAST TO THE SOUTH COAST OF SPAIN

RIBADESELLA TO MALAGA
1990

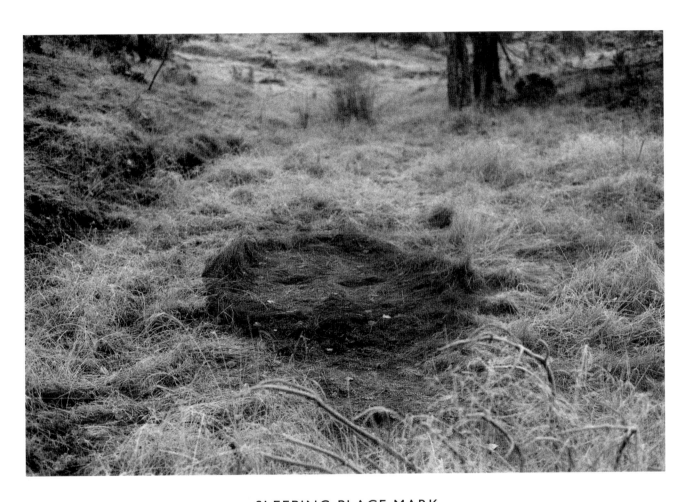

SLEEPING PLACE MARK

A NIGHT OF GRUNTING DEER A FROSTY MORNING
THE SEVENTEENTH NIGHT OF A 21 DAY WALK FROM THE NORTH COAST TO THE SOUTH COAST OF
SPAIN
RIBADESELLA TO MALAGA 1990

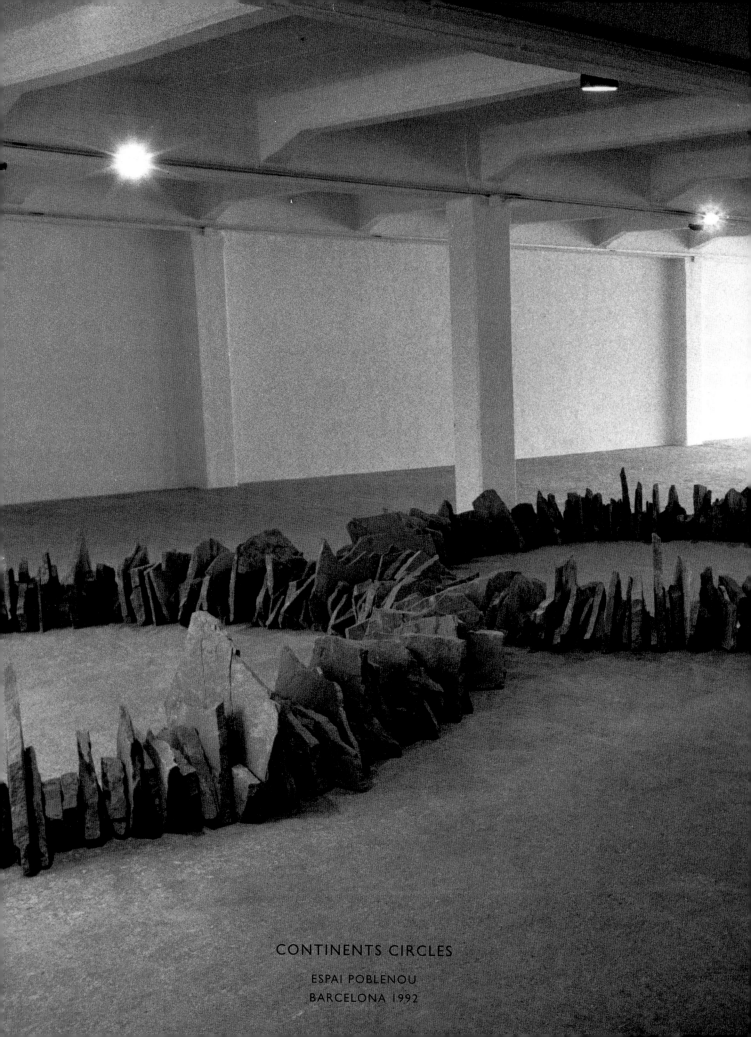

CONTINENTS CIRCLES

ESPAI POBLENOU
BARCELONA 1992

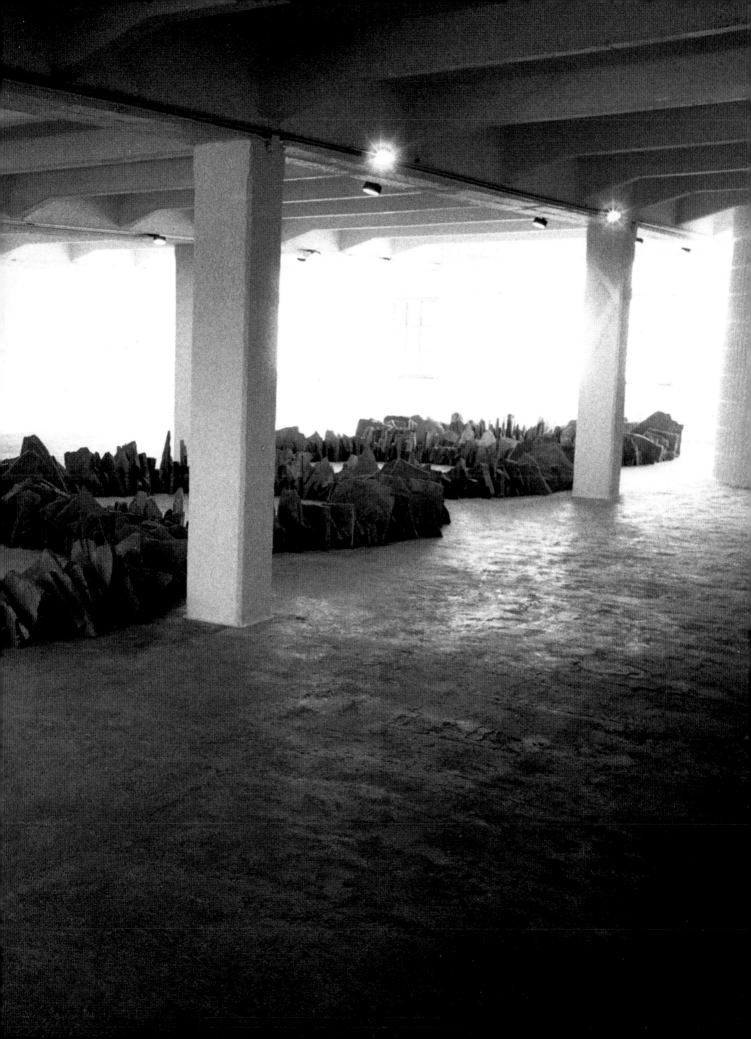

MIDDAY ON THE ROAD

NEAR CAMPO ON A WALK OF 169 MILES IN 5 DAYS FROM HUESCA IN SPAIN TO ILLARTEIN IN FRANCE
CROSSING OVER THE PYRENEES ALONG THE WAY

1994

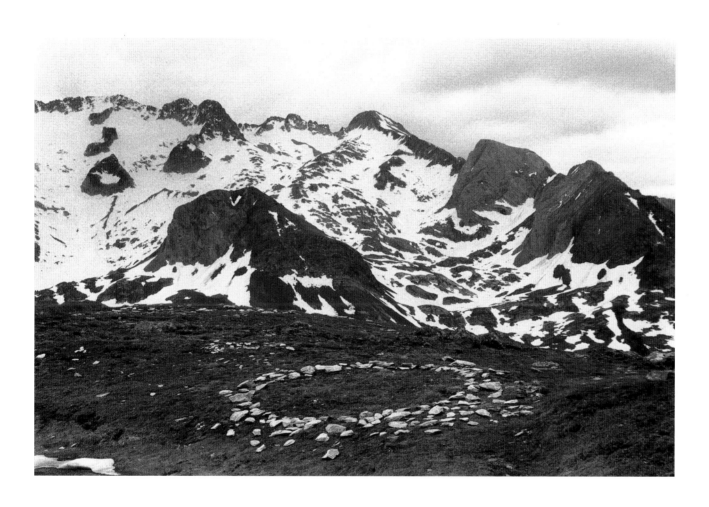

A CIRCLE IN HUESCA

PIRINEO ARAGONÉS

A WALK OF 169 MILES IN 5 DAYS FROM HUESCA IN SPAIN TO ILLARTEIN IN FRANCE
CROSSING OVER THE PYRENEES ALONG THE WAY

1994

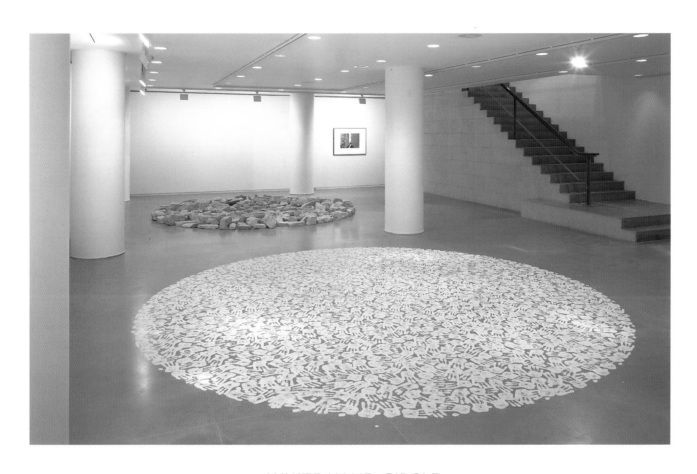

WHITE HAND CIRCLE

DIPUTACIÓN PROVINCIAL DE HUESCA
HUESCA 1995

RIVER AVON MUD DRAWINGS 1995

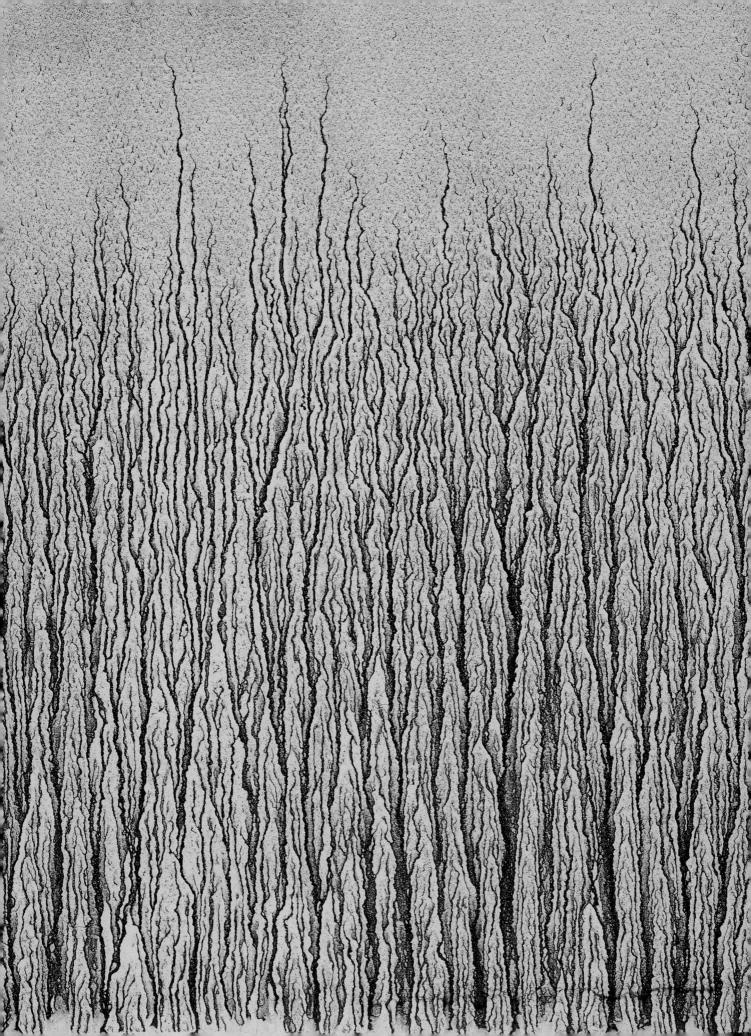

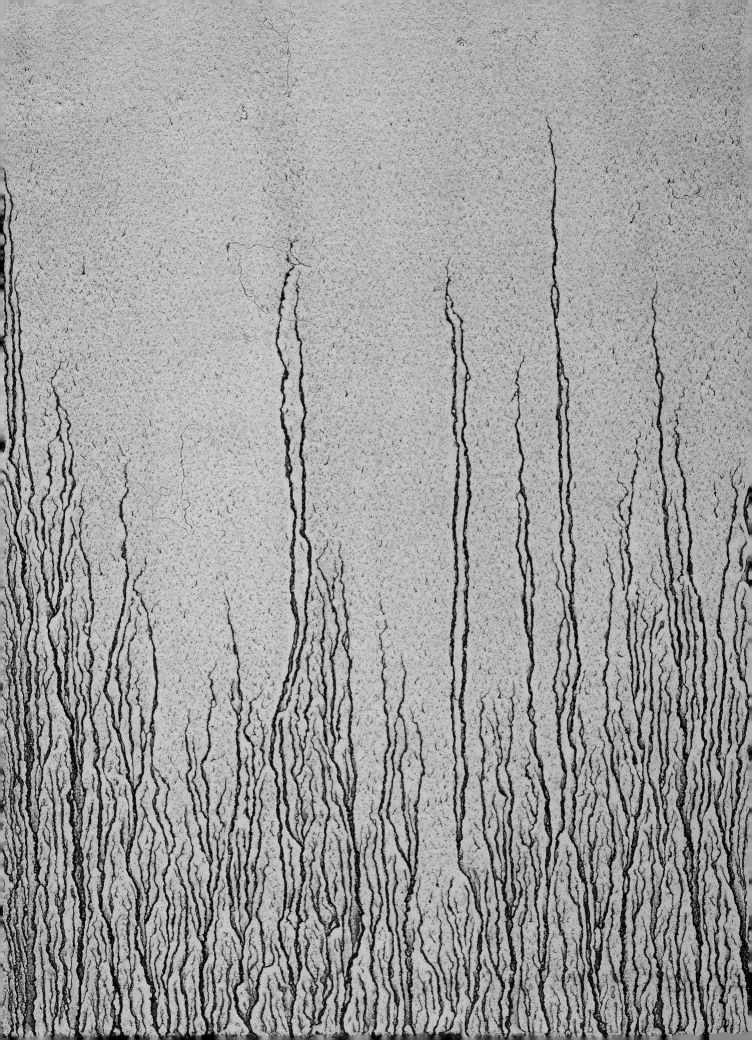

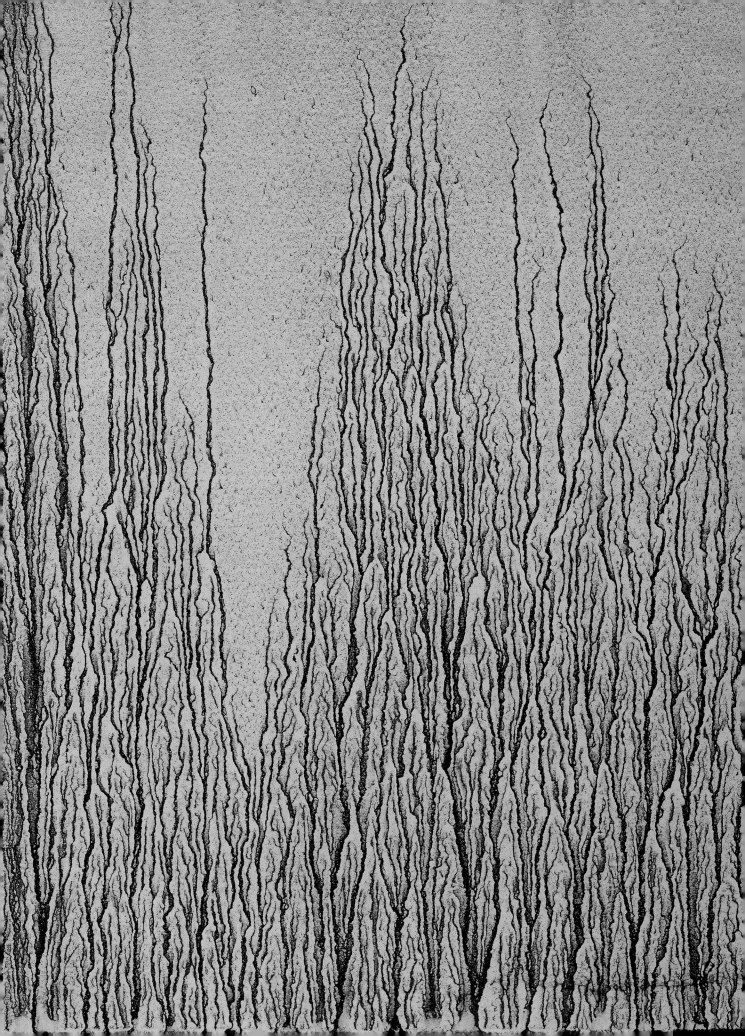

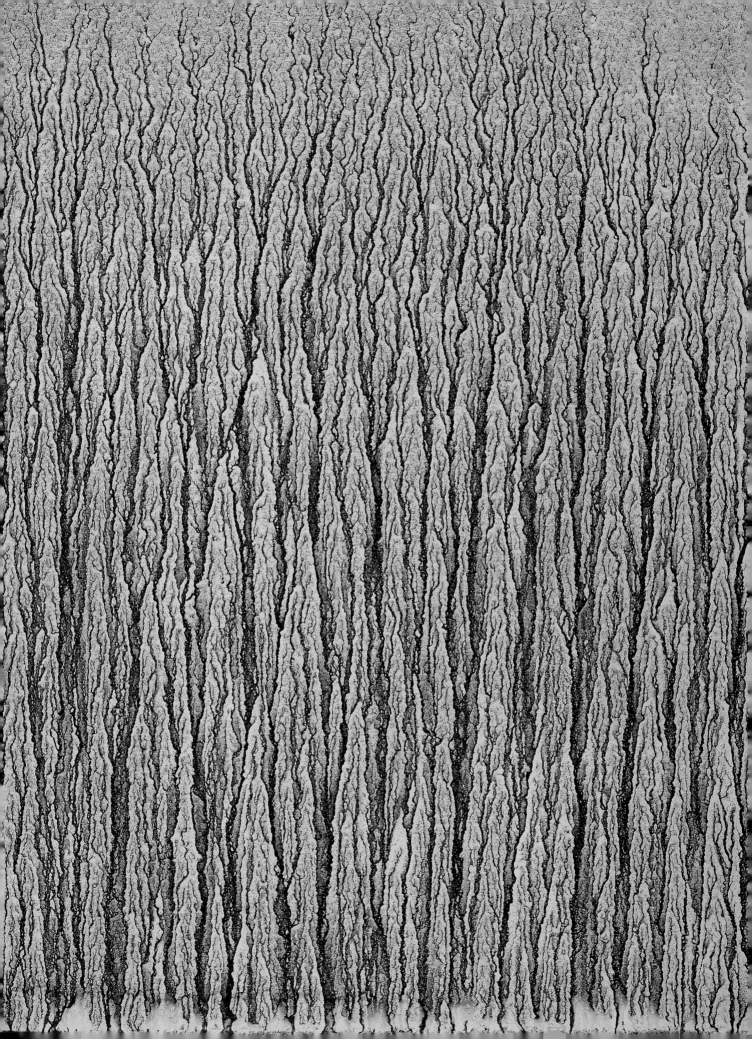

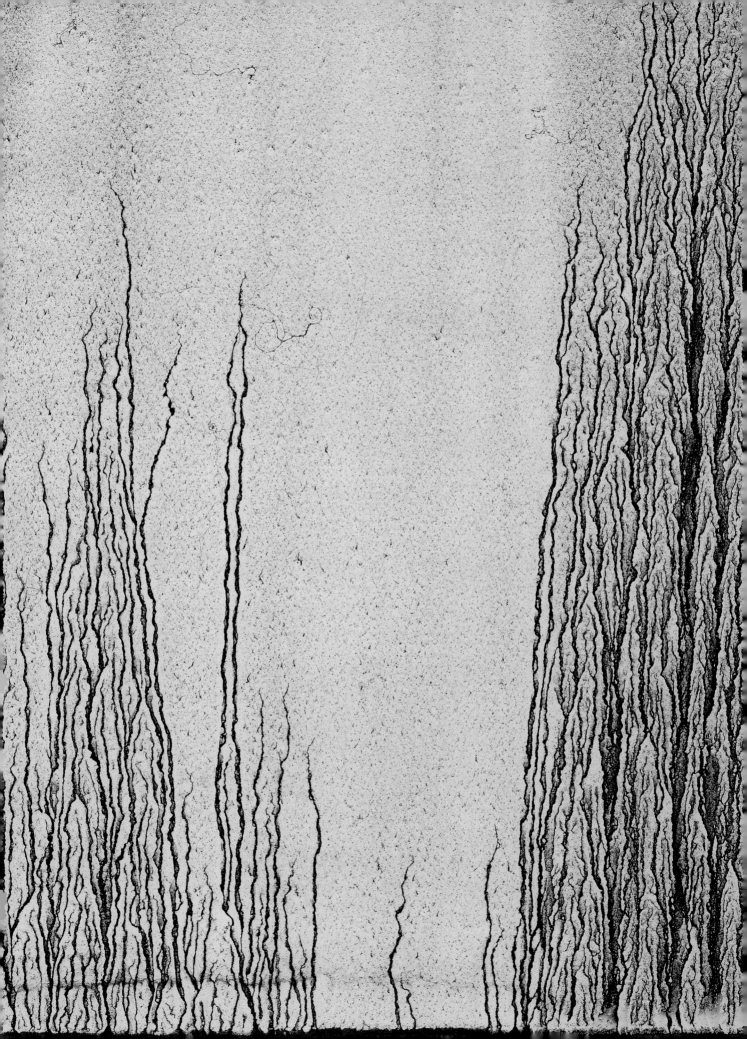

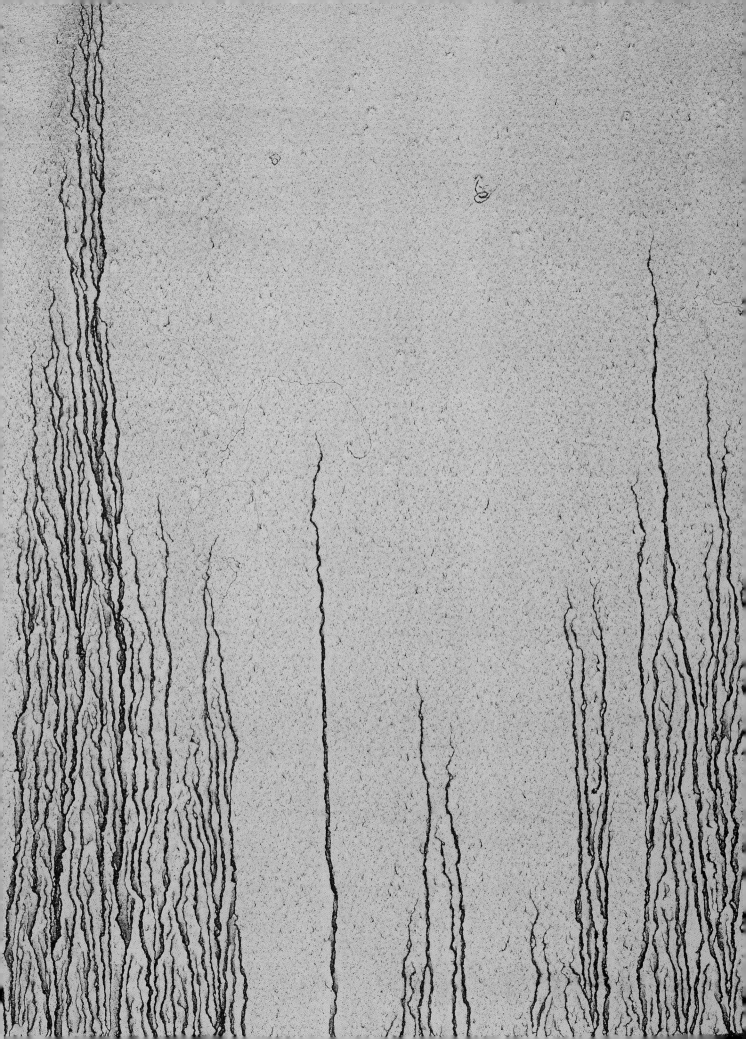

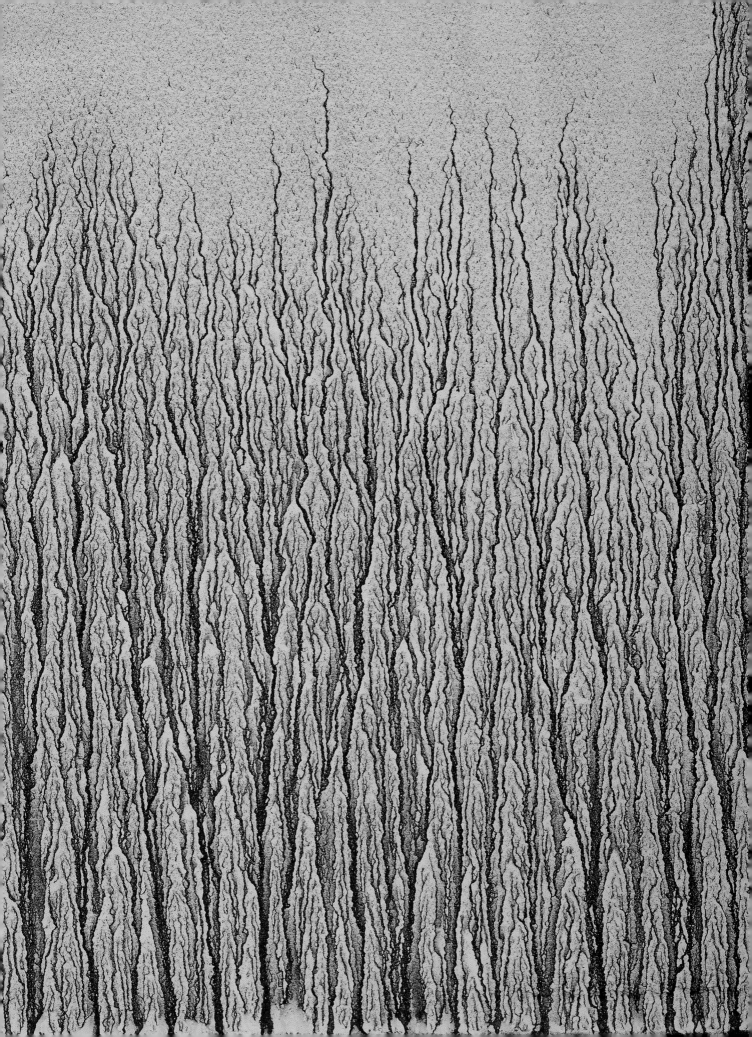

Biography

RICHARD LONG

Bristol, England, 1945
Lives and works in Bristol

1988 Kunstpreis Aachen, Germany

1989 Turner Prize, England

1990 Chevalier de l'Ordre des Arts et des Lettres, French Ministry of Culture, France

1995 Wilhelm Lehmbruck Prize, Germany

SOLO EXHIBITIONS

1968 Konrad Fischer Gallery, Dusseldorf

1969 John Gibson Gallery, New York
 Konrad Fischer Gallery, Dusseldorf
 Museum Haus Lange, Krefeld
 Yvon Lambert Gallery, Paris
 Gallery Lambert, Milan

1970 Dwan Gallery, New York
 Stadtisches Museum, Monchengladbach
 Konrad Fischer Gallery, Dusseldorf

1971 Gian Enzo Sperone Gallery, Turin
 Museum of Modern Art, Oxford
 Art and Project Gallery, Amsterdam

1972 Whitechapel Art Gallery, London
 The Museum of Modern Art, New York
 Projects, Yvon Lambert Gallery, Paris

1973 Stedelijk Museum, Amsterdam
 Wide White Space, Antwerp
 Konrad Fischer Gallery, Dusseldof
 Lisson Gallery, London

1974 John Weber Gallery, New York
 Scottish National Gallery of Modern Art, Edinburgh
 Lisson Gallery, London

1975 Konrad Fischer Gallery, Dusseldorf
 Wide White Space, Antwerp
 Yvon Lambert Gallery, Paris
 Art and Project Gallery, Amsterdam
 Rolf Preisig Gallery, Basel
 Plymouth School of Art, Plymouth

1976 Gian Enzo Sperone Gallery, Rome
 Konrad Fischer Gallery, Dusseldorf

1976 Wide White Space, Antwerp
 Lisson Gallery, London
 British Pavilion, Venice Biennale, Venice
 Art Agency Tokyo, Tokyo
 Arnolfini Gallery, Bristol
 Sperone Westwater Fischer Gallery, New York

1977 Whitechapel Art Gallery, London
 Art and Project Gallery, Amsterdam
 Gallery Akumalatory, Poznan
 Rolf Preisig Gallery, Basel
 Lisson Gallery, London
 Kunsthalle Bern, Bern
 National Gallery of Victoria, Melbourne
 Art Gallery of New South Wales, Sydney

1978 Art and Project Gallery, Amsterdam
 Yvon Lambert Gallery, Paris
 Konrad Fischer Gallery, Dusseldorf
 Lisson Gallery, London
 Park Square Gallery, Leeds
 Sperone Westwater Fischer Gallery, New York
 Austellungsraum Ulrich Ruckriem, Hamburg

1979 Ink Gallery, Zurich
 Anthony d'Offay Gallery, London
 Rolf Preisig Gallery, Basel
 Orchard Gallery, Londonderry
 Photographic Gallery, Southampton
 University of Southampton, Southampton
 Stedelijk van Abbemuseum, Eindhoven
 Lisson Gallery, London
 Art Agency, Tokyo
 Museum of Modern Art, Oxford

1980 Karen and Jean Bernier Gallery, Athens
 Art and Project Gallery, Amsterdam
 Fogg Art Museum, Harvard University, Cambridge
 Sperone Westwater Fischer Gallery, New York
 Anthony d'Offay Gallery, London
 Konrad Fischer Gallery, Dusseldorf

1981 Sperone Westwater Fischer Gallery, New York
 Graeme Murray Gallery, Edinburgh
 Konrad Fischer Gallery, Dusseldorf
 Anthony d'Offay Gallery, London
 David Bellman Gallery, Toronto
 CAPC, Musee d'Art Contemporain de Bordeaux, Bordeaux

1982 Art and Project Gallery, Amsterdam
 Yvon Lambert Gallery, Paris
 Flow Ace Gallery, Los Angeles
 Sperone Westwater Fischer Gallery, New York
 National Gallery of Canada, Ottawa

1983 David Bellman Gallery, Toronto
 Arnolfini Gallery, Bristol
 Anthony d'Offay Gallery, London
 Tucci Russo Gallery, Turin
 Art Agency, Tokyo
 Century Cultural Centre, Tokyo
 Konrad Fischer Gallery, Dusseldorf

1984 Coracle Press, London
 Lucio Amelio Gallery, Naples
 Gallery Crousel-Hussenot, Paris
 Jean Bernier Gallery, Athens
 Sperone Westwater Gallery, New York
 Dallas Museum of Art, Dallas
 The Butler Gallery, Kilkenny Castle, Kilkenny
 Orchard Gallery, Londonderry
 Anthony d'Offay Gallery, London
 Konrad Fischer Gallery, Dusseldorf

1985 Buchmann Gallery, Basel
 Anthony d'Offay Gallery, London
 Abbot Hall, Kendal
 Malmö Konsthall, Malmö
 Padiglione d'Arte Contemporanea, Milan

1986 Palacio de Cristal, Madrid
 Gallery Crousel-Hussenot, Paris
 Solomon R Guggenheim Museum, New York
 Sperone Westwater Gallery, New York
 Anthony d'Offay Gallery, London
 Porin Taidemuseo, Porin, Finland
 Tucci Russo Gallery, Turin

1987 Musee Rath, Geneva
 Coracle Atlantic Foundation, Renshaw Hall, Liverpool
 Donald Young Gallery, Seattle
 Cairn Gallery, Nailsworth, Gloucestershire
 Centre National d'Art Contemporain de Grenoble and Magasin, Grenoble
 Jean Bernier Gallery, Athens

1988 Konrad Fischer Gallery, Dusseldorf
 Neue Galerie - Sammlung Ludwig, Aachen
 Anthony d'Offay Gallery, London

1989 Kunstverein St Gallen, St Gallen
 Jean Bernier Gallery, Athens
 Tucci Russo Gallery, Turin
 Coopers Gallery, Bristol Old Vic Theatre, Bristol
 Sperone Westwater Gallery, New York
 Bristol Old Vic Theatre, Bristol
 Pietro Sparta Gallery, Chagny, France
 La Jolla Museum of Contemporary Art, La Jolla
 Henry Moore Sculpture Trust Studio, Dean Clough, Halifax, Yorkshire

1990 Arnolfini Gallery, Bristol
 Anthony d'Offay Gallery, London
 Angles Gallery, Los Angeles
 Gallery Tschudi, Glarus, Switzerland
 Konrad Fischer Gallery, Dusseldorf
 The Tate Gallery, London
 Magasin 3 Konsthall, Stockholm
 Chateau de Rochechouart, Haute-Vienne, France

1991 The Tate Gallery Liverpool, Liverpool
 St Delsches Kunstinstitute und Stadtische Gallery, Frankfurt
 Hayward Gallery, London
 Galleria Tucci Russo, Turin
 Sperone Westwater, New York
 Scottish National Gallery of Modern Art, Edinburgh
 Galerie Tschudi, Glarus, Switzerland

1992 Jean Bernier Gallery, Athens
 Angles Gallery, Los Angeles
 Mead Gallery, University of Warwick, Warwick
 Fundació Espai Poblenou, Barcelona
 Konrad Fischer Gallery, Dusseldorf

1993 65 Thompson Street, New York
 ARC, Musée d'Art Moderne de la Ville de Paris, Paris
 Inkong Gallery, Seoul
 Anthony d'Offay Gallery, London
 Kunstverein Bremerhaven, Bremerhaven
 Center for Contemporary Art, Santa Fe, New Mexico
 Newen Museum Weserburg, Bremen
 Galerie Tschudi, Glarus, Switzerland
 Sperone Westwater, New York

1994 Kunstsammlung Nordrhein Westfalen, Dusseldorf
 New York Public Library, New York
 Konrad Fischer, Dusseldorf
 Sperone Westwater, New York
 Philadelphia Museum of Art, Philadelphia
 Palazzo delle Esposizioni, Rome
 The Center for Contemporary Arts of Sante Fe, Sante Fe
 The Pier Arts Centre, Stromness, Orkney

Bienal de Sao Paulo, Sao Paolo
Museum of Contemporary Art, Sydney
Sherman Galleries, Sydney
Tucci Russo, Torino, Italy

1995 Bündner Kunstverein and Bündner Kunstmuseum, Bündner
 Peter Blum, Blumarts Inc., New York
 Sala de Exposiciones de la Diputación de Huesca, Huesca, Spain
 Laura Carpenter Fine Art, Santa Fe
 Anthony d'Offay Gallery, London
 Galerie Tschudi, Glarus, Switzerland
 Konrad Fischer, Dusseldorf
 Syningarsular, Reykjavik
 Daniel Weinberg Gallery, San Francisco

1996 Setagaya Art Museum, Tokyo
 The National Museum of Modern Art, Kyoto
 Dartmoor Time, Spacex Gallery, Exeter
 AR/GE KUNST, Galerie Museum Bolzano, Bolzano
 Galerie Tschudi, Glarus, Switzerland
 Contemporary Arts Museum, Houston, Texas
 Modern Art Museum of Fort Worth, Texas

1997 Wilhelm Lehmbruck Museum, Duisburg, Germany
 The Crawford Arts Centre, St Andrews, Scotland
 Benesse Museum of Contemporary Art, Naoshima, Japan
 Sperone Westwater, New York
 Bristol City Museum and Art Gallery, Bristol
 Spazio Zero - Cantieri Culturali Alla Zisa, Palermo

1998 Kunst auf der Zugspitze, Zugspitze, Germany
 Anthony d'Offay Gallery, London

SELECTED GROUP EXHIBITIONS

1966 Galerie Loehr, Frankfurt

1968 *Young Contemporaries*, Piccadilly Galleries A3 Amalfi, London

1969 *Earth Art*, Andrew Dickson White Art Gallery, Cornell University, Ithaca, New York
 Op Losse Schroeven, Stedelijk Museum, Amsterdam
 Folkwang Museum, Essen
 When Attitudes Become Form, Kunsthalle Bern, Bern
 Land Art, Fernsehgalerie Gerry Schum, Dusseldorf

1970 *18 Paris IV 70*, Paris
 Information, The Museum of Modern Art, New York
 Six Fugitives, Museum of Contemporary Art, Chicago
 Tabernakel, Louisiana Museum, Humlebaek, Denmark

1971 Guggenheim International, The Solomon R Guggenheim Museum, New York
 Sonsbeek 71, Arnhem
 The British Avant Garde, The New York Cultural Center, New York
 Road Show, XI Bienal de Sao Paulo, British Council Touring Exhibition, Sao Paolo

1972 Actualité d'un Bilan, Yvon Lambert Gallery, Paris
 De Europa, John Weber Gallery, New York
 Documenta V, Kassel
 The New Art, Hayward Gallery, London

1974 Palais des Beaux-Arts, Brussels
 Sculpture Now - Dissolution or Redefinition, Royal College of Art, London

1975 Word Image Number, Sarah Lawrence Gallery, Bronxville, New York
 Artists Over Land, Arnolfini Gallery, Bristol

1976 Arte Inglese Oggi, Palazzo Reale, Milan
 Andre/Le Va/Long, Corcoran Gallery, Washington DC
 Functions of Drawings, Kunstmuseum Basel, Basel

1977 David Askevold, Michael Asher, Richard Long, Los Angeles Institute of Contemporary Art,
 Los Angeles
 Lisson Gallery, London
 Munster 77, Munster
 ROSC, Hugh Lane Municipal Gallery of Modern Art, Dublin
 On Site, Arnolfini Gallery, Bristol
 Europe in the Seventies, Art Institute of Chicago and tour to Hirshhorn Museum and Sculpture
 Garden, Washington DC; San Francisco Museum of Modern Art, San Francisco; The Contemporary
 Art Center, Cincinnati

1978 Peter Joseph, David Tremlett, Richard Long at Newlyn, Newlyn Art Gallery, Newlyn
 Lisson Gallery, London
 Ink Gallery, Zurich
 Made by Sculptors, Stedelijk Museum, Amsterdam
 Foundlings, Coracle Press, London

1979 *Un Certain Art Anglais,* Musee d'Art, Moderne de la Ville de Paris, Paris
 Works from the Modern Collection, The Tate Gallery, London
 Art and Project Gallery, Amsterdam
 Toasting, Gardner Centre, Brighton
 Through the Summer, Lisson Gallery, London
 Hayward Annual, Hayward Gallery, London
 Llandudno, The Native Land, Mostyn Art Gallery, London
 Matisse, Giacometti, Judd, Flavin, Andre Long, Kunsthalle Bern, Bern
 Kunst der 70er Jahre, Stadtische Galerie im Lenbachhaus, Munich
 Contemporary Sculpture: Selections from the Collection of the Museum of Modern Art, The Museum of
 Modern Art, New York
 Concept, Narrative, Document, Museum of Contemporary Art, Chicago
 Summer Group Exhibition, Sperone Westwater Fischer, New York
 The British Art Show, Mappin Art Gallery, Sheffield

1980 *Explorations in the 70's*, Pittsburgh
Plan for Art Humlebaek, Andre, Dibbets, Long, Ryman, Louisiana Museum, Humlebaek, Denmark
Pier Ocean, Hayward Gallery, London
Daniel Buren, Sol LeWitt, Richard Long, Fred Sandback, Lisson Gallery, London
Summer Group Exhibition, Sperone Westwater Fischer, New York
Venice Biennale, Venice
Kunst in Europe na 68, Museum voor Hedendaagse Kunst te Gent, Ghent
Roger Ackling, Hamish Fulton, Richard Long, Michael O'Donnell: Four Temporary Works, Penwith Gallery,
St Ives, Cornwall
Art Anglais d'Aujourd'hui, Musee d'Art et d'Histoire, Geneva
Zomertentoonstelling Eigan Collectie, Stedelijk van Abbemuseum, Eindhoven
Nature as Material, Atkinson Art Gallery, Southport and tour to Sheffield, Carlisle, Coventry
Rochdale, Newcastle-upon-Tyne
Artist and Camera, Mappin Art Gallery, Sheffield and tour to Stoke-on-Trent, Durham, Bradford

1981 *4 Artists and the Map: Image/Process/Data/Place,* Helen Foresman Spencer Museum of Art, The
University of Kansas, Lawrence, Kansas
New Works of Contemporary Art and Music, The Fruitmarket Gallery, Edinburgh
The Panoramic Image, John Hansard Gallery, University of Southampton, Southampton
Artists for Nuclear Disarmament, Acme Gallery, London
Poet's Choice, Kettle's Yard, Cambridge
Myth and Ritual in the Art of the 1970's, Kunsthaus Zürich, Zurich
Landscape: The Printmaker's View, The Tate Gallery, London
Summer Group Exhibition, Lisson Gallery, London
Toyama Now '81, Toyama Museum of Modern Art, Toyama, Japan
Natur-Skulptur, Kunstverein Stuttgart, Stuttgart
No Title: The Collection of Sol LeWitt, The Davison Art Center Gallery, Middletown, Connecticut
New Works of Contemporary Art and Music, Orchard Gallery, Londonderry
A Mansion of Many Chambers: Beauty and Other Works, Cartwright Hall, Bradford
British Sculpture in the 20th Century, Part 2: Symbol and Imagination, 1951-1980, Whitechapel Art
Gallery, London

1982 *Artists' Photographs,* Crown Point Gallery, Oakland, California
Aspects of British Art Today, Metropolitan Art Museum, Tokyo
G K Pfahler, K R H Sonderborg Max-Ulrich Hetzler GmbH, Stuttgart
Mise en Scene, Kunsthalle Bern, Bern
'60 '80 Attitudes - Concepts - Images, Stedelijk Museum, Amsterdam
Halle 6. Objekt, Skulptur, Installation, Kampnagel-Fabrik, Hamburg
Konrad Fischer, Dusseldorf
Stein, Kunsthaus Zug, Zug, Switzerland
Collection, Museum van Hedendaagse Kunst Palais des Beaux-Arts, Brussels
Gilbert and George, Richard Long, Bruce McLean, Anthony 'Offay Gallery, London
Kunst Unserer Zeit, Kunsthalle te Wilhelmshaven, Wilhelmshaven
Kunst wird Material, Nationalgalerie Berlin, Berlin
Documenta 7, Kassel
Sans Titre, Musee de Toulon, Toulon
Milestones in Modern British Sculpture, Mappin Art Gallery, Sheffield

1983 *Landscape Prints The Gallery*, Brighton Polytechnic, Brighton
Art in Aid of Amnesty, Work of Art Gallery, London
Photography of Contemporary Art, National Museum of Modern Art, Tokyo

Landscape: Art and the Land, Rochdale Art Gallery, Rochdale
Sessanta Opere, Massimo Minini, Brescia
DE STATUA, Stedelijk van Abbemuseum, Eindhoven
The Sculpture Show, Serpentine Gallery and Hayward Gallery, London
Mythos and Ritual in der Kunst der 70er Jahre, Kunstverein, Hamburg
New Art, The Tate Gallery, London
Works on paper, Anthony d'Offay Gallery, London
ARS 83, Museum of the Atheneum, Helsinki
December Exhibition, Anthony d'Offay Gallery, London
53-83 Three Decades of Artists, Royal Academy, London

1984 *The Becht Collection,* Stedelijk Museum, Amsterdam
The Critical Eye/I, Yale Centre for British Art, New Haven
Hallen fur Neue Kunst, Schaffhausen
New International Art from the FMC Collection: Acquisitions 1977-1984, Kunsthaus Zürich, Zurich
Legendes, CAPC Musee d'Art Contemporain, Bordeaux
Terrae Motus, Fondazione Amelio, Instituto per l'Arte Contemporanea, Naples
1965-1972 - When Attitudes become Form, Kettle's Yard, Cambridge
Summer Exhibition, Anthony d'Offay Gallery, London
Primitivism in 20th Century Art: An Affinity of the Tribal and the Modern, Museum of Modern Art, New York
ROSC '84, Guinness Hop Store, Dublin
Content: A Contemporary Focus 1974-1984, Hirshhorn Museum and Sculpture Garden, Washington DC
Salon d'Automne, Coracle Press Gallery at The Serpentine, London
The British Art Show, Arts Council of Great Britain, Birmingham City Art Gallery and Ikon Gallery, Birmingham
The Turner Prize Exhibition, The Tate Gallery, London
Second Nature, Newlyn Art Gallery, Newlyn
Ouverture, Castello di Rivoli, Turin

1985 *Acquisitions 1984-1985*, Fonds Regional d'Art Contemporain de Bourgogne, Dijon
L'Art et le Temps, Musee Rath, Geneva
New Art: New World, The Showrooms of Jack Barclay, London
From the Collection of Sol LeWitt, Everhart Museum, Philadelphia
La Collection du van Abbemuseum Eindhoven, Nouveau Musee, Eindhoven
Oeuvres Recentes, Galerie Crousel-Hussenot, Paris
Livres d'Artistes, Centre Georges Pompidou, Paris
Carl Andre, Gunther Förg, Hubert Keicol, Richard Long, Meuser, Reinhard Mucha, Bruce Nauman, Ulrich Ruckriem, Galerie Max Hetzler, Cologne
20 Oeuvres de la Collection Rhone-Alpes, Fonds Regional d'Arte Contemporain, Lyon
Hand Signals, Ikon Gallery, Birmingham

1986 Anthony D'Offay Gallery, London
Entre el Objeto y la Imagen, Palacio de Velázquez, Madrid
Centre National des Arts Plastique, Dijon
Falls the Shadow: Recent British and European Art, Hayward Gallery, London
Boldenskulptur, Kunsthalle Bremen, Bremen
New Art: New World, (Exhibition/Auction) Christies, London
Collection Souvenir, Le Nouveau Musee, Villaurbanne
Un Aspect des Collections de FRAC Bretagne, Rennes

Entre l'Objecte i la Imatge, Fundació Caixa de Pensions, Barcelona
Drawings, Sperone Westwater Gallery, New York
La Traversee du Paysage, Centre Cultural Aragon, Lyon
De Sculptura, Vienna Festival, Vienna
Jardin Secret, Centre d'Art Contemporain, Marseille
AP Artists' Photographs, Canine di Marciana, Elba
Landscape Luhring, Augustine Hode Gallery, New York
Little Arena, Rijksmuseum Kröller-Müller, Otterlo
Lines of Time, Edy de Wilde-Lezing, Amsterdam
Steine Stones, Galerie Peitre Buchmann, Basel

1987 *A Quiet Revolution,* San Francisco Museum of Modern Art, San Francisco; Museum of Contemporary Art, Chicago; Newport Harbor Art Museum, California; Hirshhorn Museum and Sculpture Garden, Washington DC; Albright-Knox Art Gallery, Buffalo, New York
About Sculpture, Anthony D'Offay Gallery, London
British Art in the 20th Century, Royal Academy of Art, London; Staatsgalerie Stuttgart, Stuttgart
British Art in the 1980's, Liljevalch Konsthall, Stockholm; Sara Hilde Museum, Tampere
The Unpainted Landscape, The Scottish Arts Council Touring Exhibition, Edinburgh
Looking West, Newlyn Art Gallery, Penzance; Royal College of Art, London
Collection Agnes et Frits Becht, Centre Regional d'Art Contemporain, Midi-Pyrenees
Homage to Beuys, The Fruitmarket Gallery, Edinburgh
L'Etat des Choses 2, Kunstmuseum Luzern, Luzern
Wall Works, Cornerhouse, Manchester
The Turner Prize Exhibition, The Tate Gallery, London
FRAC Aquitaine, Centre Culturel de Dax, Dax
Focus on British Art, Galerij S 65, Aalst

1988 *Sculpture in the Close Jesus College,* Cambridge University, Cambridge
New Sculpture/Six Artists, The Saint Louis Art Museum, Saint Louis
Starlit Waters: British Sculpture, An International Art 1968-1988, The Tate Gallery, Liverpool
Productions, Victoria Miro Gallery, London
Donald Judd, Richard Long, Kristjan Gudhundsson, The Living Art Museum, Reykjavik; Graeme Murray, Edinburgh; Diane Brown Gallery, New York

1989 *Bilderstreit,* Ludwig Museum, Cologne
Hortus Artis, Castello di Rivoli, Turin
Magiciennes de la Terre, Grand Halle de la Villette, Paris; Guggenheim Museum, New York
Istanbul Biennial, Istanbul
Einleuchten (Illuminations), Deichtorhallen, Hamburg [Curated by Harald Szeeman]

1990 *Paul Brand, Terje Roalkvam, Dag Skedsmo, Richard Long,* Wang Kunsthandel, Oslo
Daniel Buren, On Kawara, Joseph Kosuth, Richard Long, Gallery 36, Tokyo
The Journey, Lincoln Cathedral, Lincolnshire
Collection, CAPC Musee, Bordeaux
Signs of Life: Process and Materials 1960-90, Institute of Contemporary Art, Philadelphia
Richard Long, On Kawara, Lawrence Weiner, Galerie Ghislaine Hussenot, Paris
John Baldessari, Lothar Baumgarten, Christian Boltanski, Jean Marc Bustamante, Richard Long, Galeria Marga Paz, Madrid
Le Diaphane, Musee des Beaux-Arts de Tourcoing, France

1991 *Hamish Fulton, Richard Long,* Galeria Weber, Alexander y Cobo, Madrid
Bronze Steel Stone Wood: Carl Andre, Ellsworth Kelly, Richard Long - Three Installations of Sculpture,
Anthony d'Offay Gallery, London
Den Gedanken auf der Spur bleiben, Museen Haus Lange und Haus Esters, Krefeld
L'Art du Paysage, Chateau de Kerguehennec, Brittany, France
La Collection, Chateau de Rochechouart, Haute-Vienne, France

1992 *La Realidad Desautorizada,* Galería Gamarra y Garrigues, Madrid
Richard Long, Gerhard Richter, Lawrence Weiner, Anthony d'Offay Gallery, London
Luciano Fabro, Dan Flavin, Jannis Kounellis, Sol LeWitt, Richard Long, Mario Merz, Bruce Nauman, Stein
Gladstone/Barbara Gladstone Gallery, New York
Sculpture in the Close Jesus College, Cambridge

1993 *Gravity and Grace,* Hayward Gallery, London
Out of Sight Out of Mind, Lisson Gallery, London
Visione Britannica, Valentina Moncada Gallery and Pino Casagrande Studio, Rome
Feuer Erde Wasser Luft: Die Vier Elemente, Deichtorhallen, Hamburg
La Collection, Musee Departemental d'Art Contemporain de Rochechouart, Haute-Vienne, France
Galerie Lelong, New York
Out of the Mist, Exeter City Museums & Art Gallery, Exeter
Sculpture, Leo Castelli Gallery, New York

1994 Philadelphia Museum of Art, Philadelphia
24: Recent Painting and Sculpture, Anthony d'Offay Gallery, London
Zappeion Hall, Athens
1969, Jablonka Gallery, Cologne
Mapping, Museum of Modern Art, New York
Artists' Impressions, Kettle's Yard, Cambridge

1995 *Drawing the Line,* Southampton City Art Gallery, Southampton; Manchester City Art Galleries,
Manchester; Ferens Art Gallery, Hull; Whitechapel Art Gallery, London

1996 *Material Imagination,* The Guggenheim Museum, Soho, New York
From the Collection Naivety in Art: A Decade of Exploration, Setagaya Art Museum, Japan
From Figure to Object: A Century of Sculptor's Drawings, Frith Street Gallery/Karsten Schubert, London
Photography exhibition, Bunkier Sztuki, Krakow, Poland
Swinging the Lead, The Old Leadworks, Bristol
Une Siècle de Sculpture Anglaise, Jeu de Paume, Paris

1997 *Treasure Island,* Centro de Arte Moderna, Lisbon
Bristol Museums and Art Gallery, Bristol
De Re Metallica, Anthony d'Offay Gallery, London
Géographiques, FRAC, Corte, Corsica
Midlands Arts Centre, Birmingham

SELECTED COLLECTIONS

Wallraf-Richartz Museum, Cologne
Stedelijk Museum, Amsterdam
The Tate Gallery, London
The Museum of Modern Art, New York
The Art Institute of Chicago, Chicago
E. Hoffmann Collection, Basel
Stedelijk van Abbemuseum, Eindhoven
Giuseppe Panza, Milan
Museum Haus Lange, Krefeld
National Gallery of Canada, Ottawa
Stadtisches Museum, Monchengladbach
Museum Boymans-van Beuningen, Rotterdam
Musee d'Art Moderne de la Ville de Paris, Paris
Art Gallery of Victoria, Adelaide
Art Gallery of Ontario, Toronto
The Crex Collection, Zurich
Louisiana Museum, Humlebaek
Kröller-Müller Museum, Otterlo
Leeds Art Gallery, Leeds
Southampton Art Gallery, Southampton
Swindon Art Gallery, Swindon
Bristol City Art Gallery, Bristol
Museum voor Hedendaagse Kunst te Gent, Ghent
Museum des 20. Jahrhunderts, Vienna
Malmö Konsthall, Karin and Jules Schyls Donation, Malmö
The Detroit Institute of Arts, Detroit
Scottish National Gallery of Modern Art, Edinburgh
Fogg Art Museum, Harvard University, Cambridge
Walker Art Center, Minneapolis
Tokyo Metropolitan Museum, Tokyo
Australian National Gallery, Canberra
CAPC, Musee d'Art Contemporain, Bordeaux
Moderna Museet, Stockholm
The Museum of the Ateneum, Helsinki
Museum Ludwig, Cologne
Cleveland Museum of Art, Ohio
Carnegie Institute, Pittsburgh
Centre George Pompidou, Paris
Arts Council of Great Britain, London
Ackland Art Museum, USA
Philadelphia Museum of Art, Philadelphia
Hiroshima City Museum of Contemporary Art, Hiroshima